ETERNAL WALES

First impression: 2002

© Gwynfor Evans (words), Marian Delyth (images) and Y Lolfa Cyf., 2002

Design: Marian Delyth
Translation: Mihangel Morgan

ISBN: 0 86243 608 7

Casebound in Wales by Principal Bookbinders Ltd, Ystradgynlais

Published and printed in Wales by
Y Lolfa Cyf., Talybont, Ceredigion SY24 5AP
e-mail ylolfa@ylolfa.com
website www.ylolfa.com
phone (01970) 832 304
fax 832 782
isdn 832 813

ETERNAL
WALES

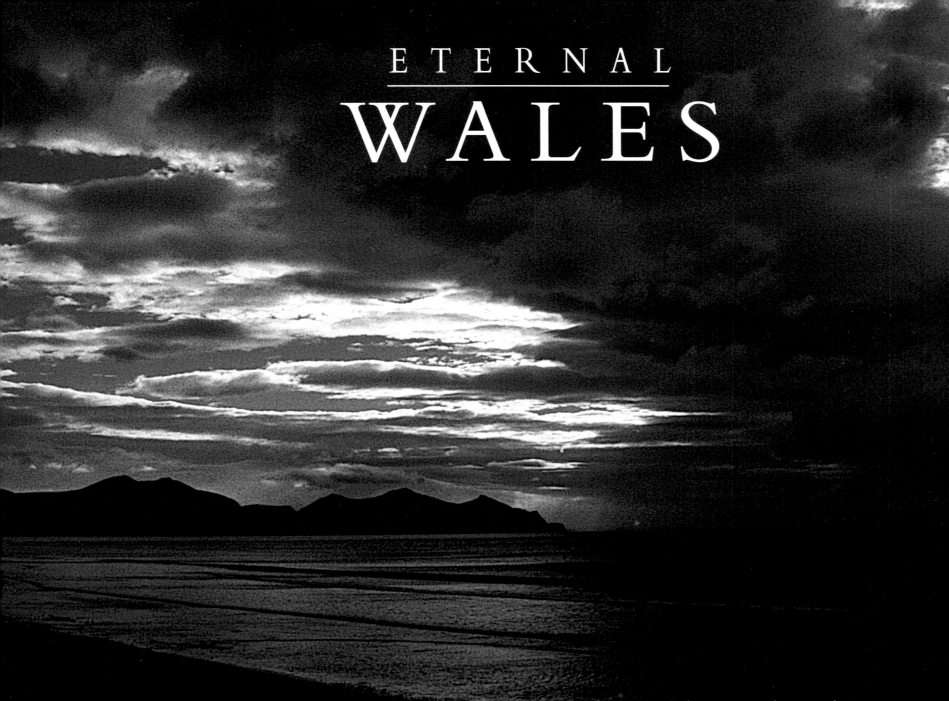

words Gwynfor Evans • *images* Marian Delyth • *translation* Mihangel Morgan

Hywel Coetmor ap Gruffudd Fychan ap Dafydd Gam's Tombstone, Gwydir Chapel, Llanrwst

Contents

Introduction

I write these words whilst sheltering from the elements, deep in the Ewyas valley in Gwent. I discovered this place when I was a student and I have returned here on what could be described as an annual pilgrimage ever since. No single word or image can adequately convey the complex weave of senses which forms my experience of being here. But I have attempted many times to capture the essence of the place on film. Despite its remote location, I have never felt lonely here; the solitude is conducive to a mood of creative contemplation. The haunting beauty of the place has been enriched by the souls of many centuries and their influence still resounds here.

I was constantly aware of the history that is embedded in the land when I took these pictures. Every step I took were steps which bridged the layers of centuries. Sometimes a shaft of light would cross the moorland, or dark clouds would darken the unfolding hills or the waves of a vast seascape. The elements are an integral part of our history. Gwynfor's acquaintance with our past illuminates the journey taken in this book. The journey was not mapped chronologically or geographically, but it is a journey of discovery of our history presented in a collection of impressions in words and images. The places and characters, as infinitely different and colourful as the patches of cloth found in our traditional quilts, are sewn together within these covers.

I thank Y Lolfa for suggesting that I should work in harness with Gwynfor on this book. The experience was entertaining, thought-provoking and a privilege which I shall always treasure. I could only sit back in awe and listen to his story-telling and hear him reeling the dates of every period in our history! It was my admiration and respect for his strong leadership and valiant acts of sacrifice and heroism for the sake of Wales throughout his life that inspired me to persevere to complete this book. These images which were created with deep affection I present to him.

Had I not attended the Art College at Newport and followed my usual trait of wandering along country lanes, I would not have found this place in the Black Mountains with the secrets of its long history. This collection of images and histories will hopefully encourage all of us to rediscover the roots which have created us as a nation and to spend some time reflecting on their significance. Understanding the past will hopefully give us the inspiration and determination to create a better future. For those who do not live here, I hope that the book gives some insight into our place in history. In this age of the soundbite and the fleeting superficial image, there is a need to pause and to contemplate what lies ahead of us and future generations in this small part of the world.

The land of Wales cannot be separated from its history, culture and language. Its beauty cannot simply be seen as "a watercolour's appeal to the mass" as described by R S Thomas. Its appreciation should not be limited to the merely aesthetic, nor should its protection be regarded as a purely environmental exercise.

I hope that this book will encourage others to travel as extensively as I did. In so doing they will experience the enduring beauty of Wales and hopefully sense the indefinable qualities inherent in its landscape – of the spiritual and the eternal.

near Abergavenny

sunset from Dinefwr Castle

Tre'r Ceiri

view from Tre'r Ceiri

Hundreds of years before Wales became the land of castles it was the land of hill fortresses. About six hundred have been discovered, and it is thought that there are more to be found. They were built during the last thousand years of the Iron Age by the forefathers of the Welsh, who were Celtic in language and culture. The Welsh Celts did not attack the land of Wales in the Iron Age, for their roots were very deep in their mother country. Their ancestors lived here in the Neolithic Age. It was not merely a relationship of history and a sense of belonging that united the Celts of Wales and the Celts that had been such a mighty force on the continent of Europe for centuries, but a relationship of language and culture.

ruins

The hill forts are most numerous in the south-west of Wales and largest in the north-east, but Tre'r Ceiri in Gwynedd is the most remarkable of all. Tre'r Ceiri stands on the summit of the Eifl on the Llŷn peninsula. The walls are thirteen feet thick, and within its bounderies there are a hundred and fifty stone huts. It was built about 200 BC. Some believe that the Romans used it as a fortress when the Irish came to Llŷn. Certainly it continued to be used during the Roman period.

There are tales in the area about Gwrtheyrn (Vortigern) the mighty Briton king who became so unpopular because, it is said, he invited Englishmen in the fifth century to help him to defend the country against attacks from the Picts. Nant Gwrtheyrn is found between the Eifl and the sea.

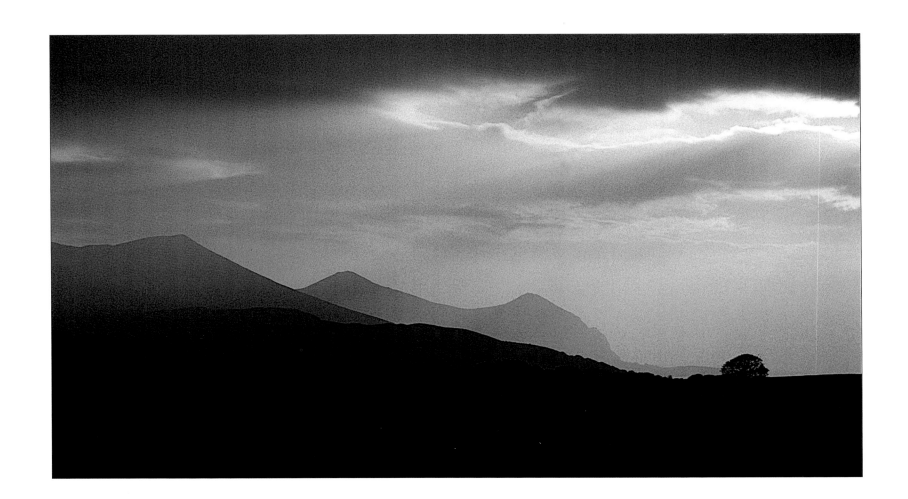

Pentre Ifan

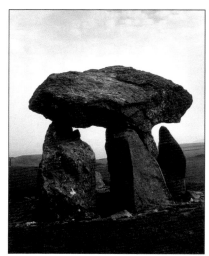

Almost four centuries ago the magnificent megalith of Pentre Ifan was described as one of the wonders of the county by George Owen, a historian from Pembrokeshire. The original cairn was about a hundred and fifty feet long and sixty feet wide, and the inner sides of the chamber are nine feet high, which is higher than usual. Although there are cromlechs of greater size in Wales, the situation and beauty of Pentre Ifan has made it an invincible symbol of the ancient nature of our country. This burial chamber is as old as the pyramids of Egypt, and it was created long before the coming of the Celts. In fact, there are more centuries between the making of Pentre Ifan cromlech and the birth of

Carreg Sampson, another cromlech in Pembrokeshire

Christ than there are between his birth and our time.

It was built by the first people to live a settled life in Wales. They were farmers that grew barley, although cattle, sheep, goats and pigs were their usual food. They felt the presence of spiritual powers around them everywhere, in a tree and a river, in a mountain and in lakes and leaves. They worshipped their forefathers, and it seems that a cult of the dead inspired the creation of the megaliths. Through huge rock arrangements such as Pentre Ifan the dead were able to pass to the next world, but their spirits continued to inhabit the grave. It is possible that the belief in the 'little people' was drawn from this. More than one writer has noticed the peaceful spirit which surrounds Pentre Ifan, as it looks to the sea over verdant slopes. In the presence of the massive stones it is not hard to imagine '*Y duwiau na ŵyr neb amdanynt nawr*' ('The gods that no one knows about by now').

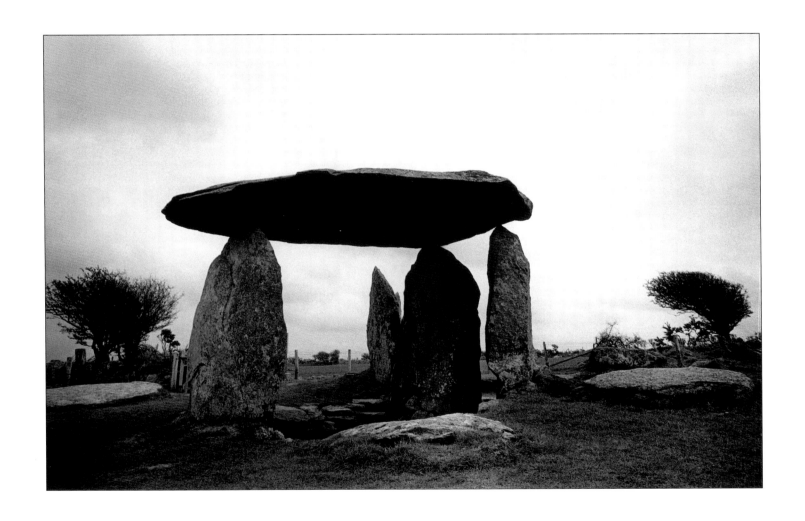

Preselau

To R T Jenkins Preselau Mountain was the sanctuary of the old gods and giants of the ancient world. From here came the huge blue stones of Stonehenge. We wonder at the technical and organisational ability of the people of the Neolithic Age in moving these immense rocks two hundred miles to the flatlands of southern England, and are amazed at the depth of religious motivation that drove such a difficult undertaking. Preselau was a holy mountain in that far off time.

Dyfed of the *Mabinogion* is a land of magic and mystery – the land of Pwyll Lord of Dyfed and Rhiannon, the land of the old gods that walked the earth disguised as human beings. In a later age, when Brynach the Irishman and a multitude of Irish people lived there, the region of Preselau was filled with memories of Arthur, as the numerous places named after him testify.

Stone Circle, Mynachlog Ddu

For us today this is the land of Waldo, the Welsh poet who was brought up in Mynachlog Ddu,

Mur fy mebyd, Foel Drigarn, Carn Gyfrwy, Tal Mynydd,

Wrth fy nghefn ym mhob annibyniaeth barn.

(Wall of my youth, Foel Drigarn, Carn Gyfrwy, Tal Mynydd,

Backing me in all independence of judgement.)

Waldo's Memorial Stone

This *annibyniaeth barn* was demonstrated when the War Office decided, a year after the Second World War, to take most of the land belonging to the farmers in the Mynachlog Ddu area and to turn Preselau into a practice ground for the War Office, like Epynt. The solid strength and unanimous objection of the people of the neighbourhood – under the leadership of two brave ministers, Parri Roberts the Baptist and Joseph Jenkins the Independent – halted the vandalism.

standing stones, Mynachlog Ddu

Porth Glais

The importance of Porth Glais, to Tyddewi (St David's) becomes clear when considering the history of the Celts in Wales. The most convenient harbour for this little metropolis was Porth Glais, which faced the Irish Sea – that was truly a Celtic

cottage, Porth Glais

sea in those days. Monks, merchants, craftsmen and artists sailed this sea between the Celtic countries and even as far as the Mediterranean.

This is surely why, apart from its convenient and central position, Dewi Sant (St David) was attracted to build the monastery there, where it became the chief Celtic church in Wales. Certainly, many monks came over the sea, especially from Ireland, and it is more than likely that Dewi spoke Irish as well as Welsh. For centuries the Irish were numerous in the land of Dyfed, as the many Ogam stones testify, and an Irish settlement, towards the end of the Roman period, gave the province its royal lineage. Quite possibly Macsen Wledig (Magnus Maximus) was responsible for that settlement as is suggested by an inscription in Latin and Ogam on a memorial stone to a man named Voteporix who lived near Arberth. Voteporix is one of the kings that felt the wrath of Gildas, in *Protectoris*, which implies that one of his forefathers belonged to the retinue of a Roman emperor.

It is from Porth Glais that the Welsh princess Marchell sailed to marry Anlach, an Irish prince – a union that produced Brychan Brycheiniog, a saint and a king.

Five centuries after Dewi, the learned Sulien was bishop of Tyddewi. It seems probable that he also sailed from Porth Glais to spend five years in Scotland and thirteen in Ireland, and this is evidence of the continuation of the relationship between Wales and the other Celtic countries. It was Sulien who blessed Gruffudd ap Cynan and Rhys ap Tewdwr when they arrived at Porth Glais with an Irish army before the battle of Mynydd Carn, where their victory captured the thrones of Gwynedd and South Wales for them.

statue, St David's Cathedral

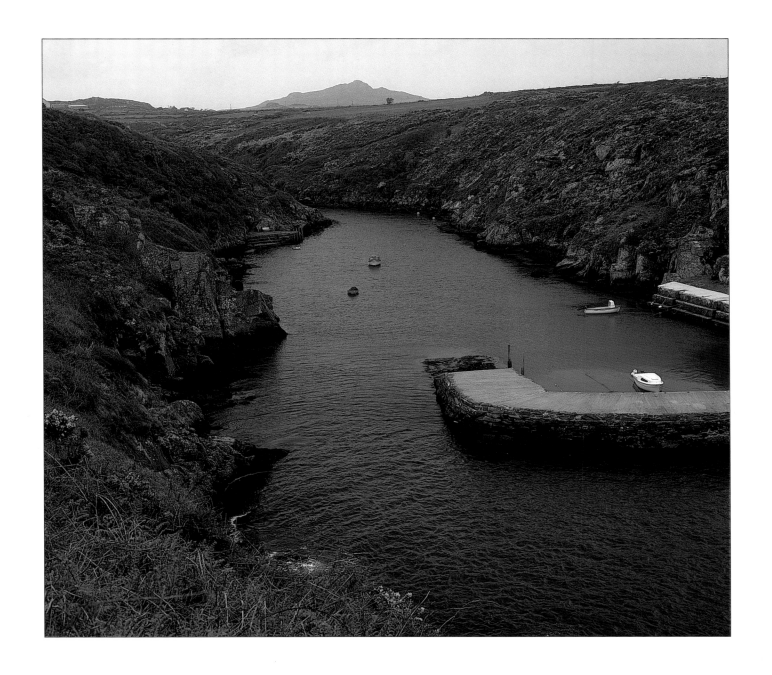

Pembrokeshire coast

Bangor Is-coed

The Age of the Saints, from the fifth century to the seventh, was the most creative period seen in Wales. A political system was established that separated Wales from her neighbours and, more fundamentally, the Welsh language developed, the Christian faith spread and Wales was moulded into a nation.

Nine years after the death of Dewi (St David), Augustine was sent by the Pope with some scores of monks on a mission to England, to Christianise the English. They landed in Kent, according to Bede, the great English historian. Augustine was met by a deputation of Welsh monks from the monastery at Bangor Is-coed (Bangor-on-Dee), a pearl of Welsh Christian culture. He aimed to get three things from the Celtic church, that they give up their customs, submit to Augustine as archbishop of Canterbury, and help him to evangelize to the English. But the Welsh would not turn their backs on their traditions, says Bede, without obtaining the consent of their people first. They went home to discuss the proposal.

Before the second meeting they went to a wise hermit for advice. He told them to cooperate if Augustine could prove himself a true man of God, by showing he was kind and humble. If Augustine rose to his feet as the monks drew near to him

they should listen to him, because this proved that he was the servant of God; but if he displayed pride by remaining seated then they should not cooperate. Augustine was enraged by their attitude, according to Bede, and he threatened war and revenge.

The vengeance came ten years later when Northumbria attacked Powys. In a great battle near Chester in 616 the Welsh were overpowered. Selyf, the king of Powys, the son of Cynan Garwyn, for whom Taliesin wrote an eulogy, was killed. Not far from the battlefield stood twelve hundred monks from Bangor Is-coed praying for their compatriots. They were all killed in a massacre reminiscent of the slaughter of the druids of Ynys Môn (Anglesey) some six centuries earlier. 'This is how,' says Bede with relish, 'the prophecy of the holy bishop Augustine was fulfilled.'

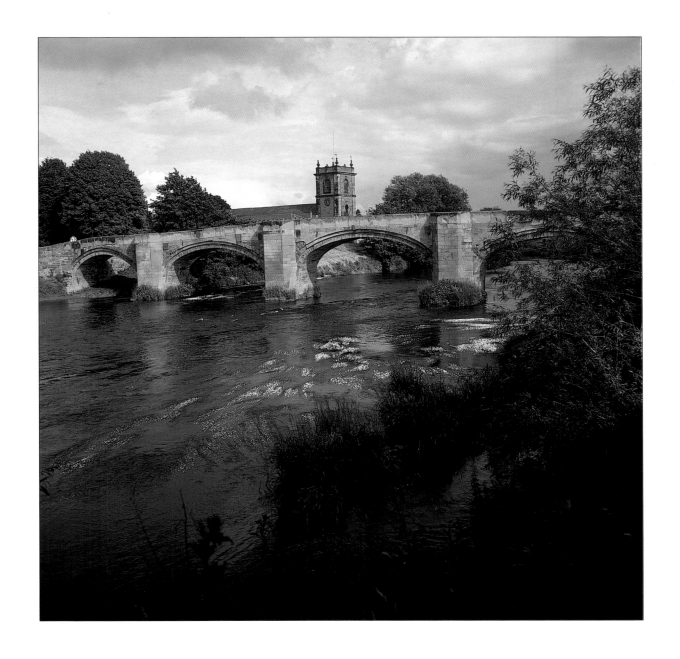

Glyn y Groes: Valle Crucis Abbey

The religious order which gave the strongest support to the Welsh during their heroic struggle against the Normans was the Cistercians (also called the White Brothers), an ascetic order totally independent of Canterbury. They were patrons of the arts and of Welsh scholarship; *Brut y Tywysogion,* for example, was kept at Ystrad Fflur (Strata Florida). It was at Glyn y Groes Abbey

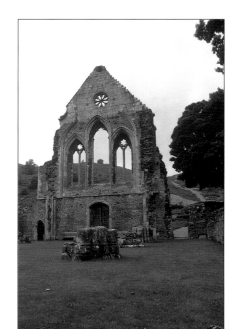

(established by the forefathers of Owain Glyndŵr) that the old soldier-poet Guto'r Glyn died, the main supporter in his day of the tradition of Taliesin, according to Saunders Lewis.

Near Glyn y Groes the king of Powys, Cyngen, erected a remarkable column in about 825. The inscriptions on the stone were copied by Edward Lhuyd, the greatest antiquarian ever seen in Wales. The inscription claims that King Cyngen was descended from Gwrtheyrn (Vortigern, a king of Powys, possibly, and the king-superior of Britain) and Sevira (the daughter of Macsen Wledig).

Macsen Wledig (Magnus Maximus) holds a place of great importance in the early mythology and history of the Welsh. He was claimed as their founder by a number of royal families including that of Cyngen. Before his declaration as Roman Emperor in the year 383, when he took the Roman soldiers from Wales, he apparently recognised the independence of the Welsh under the rulership of their own leaders.

Dr John Davies says, 'It is not fanciful to accept 383 as the year of the conception of the Welsh nation and to accept Macsen Wledig as the father of that nation.'

Over a thousand years after the departure of Macsen Wledig from these shores the War of Independence for Wales was fought under the leadership of Owain Glyndŵr. Glyndŵr disappeared after twelve years of fighting. There is a lovely tale about him at the end of his life walking early in the morning near Glyn y Groes when he met the abbot. 'You rose early, Abbot,' said Glyndŵr. 'No, sir,' answered the abbot, 'it is you that rose too early.'

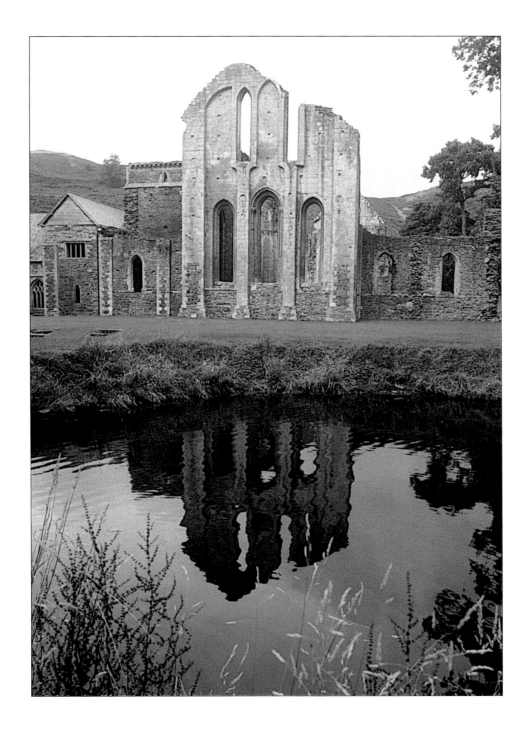

Ystrad Fflur

Dafydd ap Gwilym's memorial

For thousands of years, from the days of Taliesin and Aneirin in the sixth century until the sixteenth century, Welsh literature was one of the great literatures of Europe, in prose as well as poetry.

The greatest Welsh poetic genius of the Middle Ages, without a doubt, and one of the greatest in Europe, was Dafydd ap Gwilym. It seems that he was born in Brogynin in the parish of Llanbadarn Fawr. While some believe that Talyllychau Abbey (Talley) is his resting place, the general opinion is that his remains lie in the monastery of Ystrad Fflur (Strata Florida).

Sir Thomas Parry, the foremost authority on Dafydd, said, 'Of all the poets of Wales, before him and after him… no one else has the same perception, the same amazement in observing the world around him, the same faculty for sensing the refined things in life.'

This great poet was born within a generation of the Anglo-Norman invasion, a son of Gwilym Gam, a nobleman belonging to one of the most influential families in the old kingdom of the South. He spent much of his youth with his uncle, Llywelyn ap Gwilym, constable of Newcastle Emlyn, who was also a learned poet. Dafydd ap Gwilym travelled all over Wales, and his poems are set in places from Gwynedd to Gwent. He dedicated seven poems to Ifor Hael, a friend and patron from Basaleg near Casnewydd-ar-Wysg (Newport).

The love of women and the world of nature are the main themes of his poems. Thomas Parry proved that two of the sweethearts he wrote for, namely Morfudd and Dyddgu, were not merely poetic figures but actually existed. His songs reflect the confidence that thrived among the Welsh. He was followed by two centuries of great poets who created the most brilliant poetry in our history.

decorative floor tiles, Ystrad Fflur Monastary

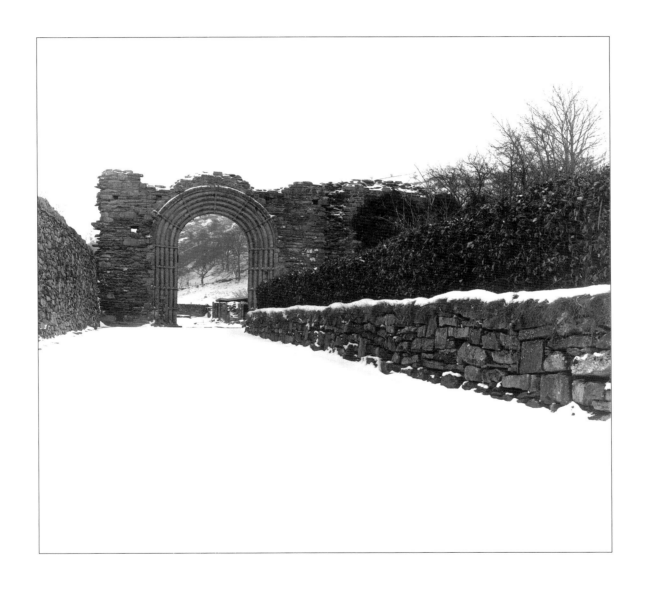

Ystrad Fflur

Tywi Valley

Dinefwr

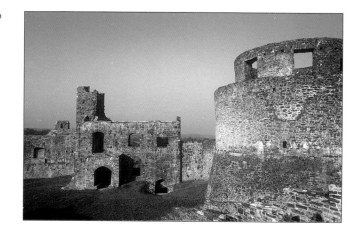

The name Dinefwr suggests it was an old fortress, pre-Roman possibly. It seems to have been one of the chief courts of the Southern kingdom, if not the primary court, at the time of Hywel Dda. We know that it was the main court for the most significant descendent of Hywel Dda, Rhys ap Gruffydd, Prince of the South, known as Lord Rhys.

It is more than likely that Welsh would have died out in Wales as it did in the kingdoms of the Old North, if not for Rhys ap Gruffydd and the great princes of Gwynedd. If the Normans had vanquished the Welsh as thoroughly as they conquered the English, the language would have vanished, as happened to Anglo-Saxon after French was made the language of law and government in England by the victorious Normans. When Rhys was born, the Southern kingdom and all of south Wales was governed by the Normans. But his

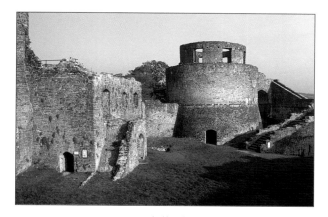

father Gruffydd, his mother Gwenllïan, and his five brothers fought bravely to regain their inheritance. By the middle of the twelfth century, when Rhys was twenty three years old, the full responsibility fell upon his shoulders. He took advantage of the troubles that beset King Henry II to establish his authority throughout the south.

For a whole generation after the death of Owain Gwynedd, Rhys was the foremost prince of Wales. The *Brut y Tywysogion* attests that he was a man of 'genial speech, fair of face, civil and just to everyone'. Lord Rhys fed the rebirth of spirit and culture in Wales. He took pride in the Welsh language as a treasure and, in setting up a conscious policy of protecting it, he ensured its honoured status. He gave his support to the Cistercians, and he was the main founder of Ystrad Fflur, as well as Talyllychau Abbey (Talley) and the Convent of Llanllŷr (Llanyre). Under his patronage the first eisteddfod ever recorded was held at Cardigan Castle in 1176.

Llanfihangel Abercywyn

Few know of the existence, fewer still have seen, the church of Llanfihangel Abercywyn, a church secreted near to the furthest point the tide reaches up the river Taf. It was possibly a stopping place for pilgrims on their way to St David's. This is one of the twelve churches that belong to the abbey of Hendy-gwyn ar Daf (Whitland).

The Cistercians were an order of monks from Citeaux in Burgundy, and they did more to support Wales than any other order. The Benedictines were used by the Normans to take land from the churches of Wales and to force their policies on the country. But as the centre of Cistercian authority for their six hundred European monasteries was in the hands of the Head Abbot in Citeaux, this order was completely independent from the King of England and the Norman establishment. The Cistercians were also called the White Brothers, and they contributed greatly to the civilization of Wales spiritually, culturally and architecturally.

detail from gravestone near church

As they were originally French, Welsh culture was enriched through them by French culture. They extended a welcome to the important people of the country as well as to the poor and ill.

Two centuries after the death of their patron, Lord Rhys, they continued to be just as supportive of another Welshman – Owain Glyndŵr. Prominent among them at that time was John ap Hywel. He was the abbot of the Cistercian Abbey of Llantarnam in the south-east, a brave man, godly and ascetic in his way of life, and an example of the idealism that maintained the cause of Glyndŵr. This abbot stirred up the soldiers' zeal before the battle by moving among them, urging them to defend their country, their homes, their wives and their children. He was killed in the battle of Pwll Melyn in Gwent – almost two and a half centuries after the founding of the Abbey of his order in Hendy-gwyn ar Daf.

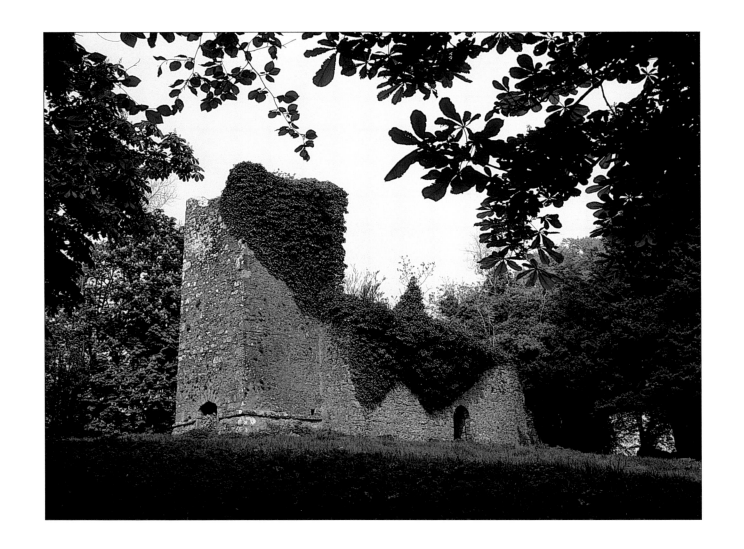

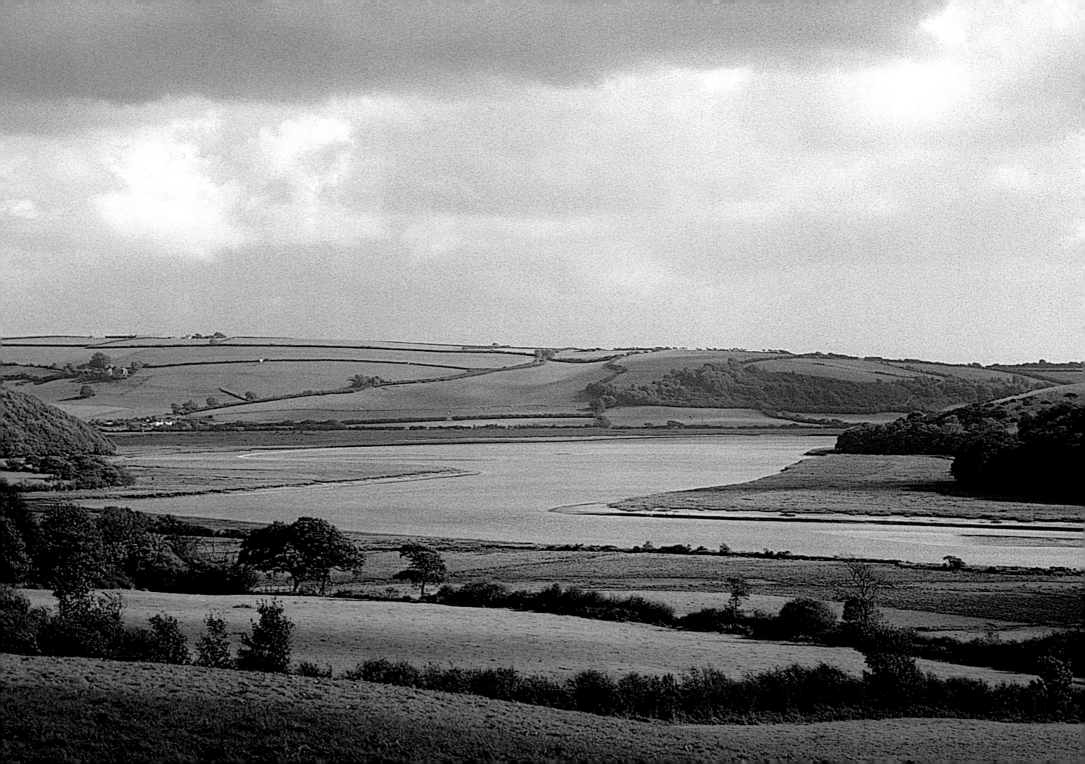

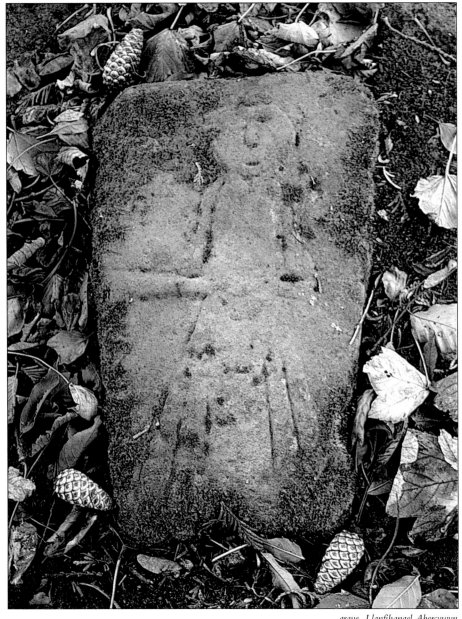

grave, Llanfihangel Abercywyn

Talyllychau Abbey

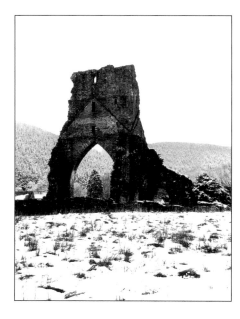

Rhys ap Gruffydd, Prince of the Southern Regions, founded Talyllychau Abbey (Talley), the only Premonstratensian abbey in Wales. The Premonstratensians, a French order, were similar to the Cistercians in their organisation, their policies and their values, and also in their choice of remote places for their abbeys. It is possible that Rhys chose this order because he had friends in England who were supporters.

Talyllychau was just as independent from the King of England and the policies of Canterbury as was Ystrad Fflur and the Cistercian abbeys, and it gave the same support to Welsh culture. Rhys accomplished similar work on the great mansions of the Welsh church that were destroyed by the Normans. In the end King Edward destroyed Talyllychau Abbey by replacing the monks with 'others of the English tongue'. But it is said that in the time of Owain Glyndŵr, English visitors to Talyllychau were fearful of coming within twenty four miles of the place.

There is an old tradition in the area that it is at Talyllychau, rather than at Ystrad Fflur, that Dafydd ap Gwilym was buried. This was recorded by Thomas Wiliems of Trefriw, the collector and copier of manuscripts, towards the end of the sixteenth century. Iolo Morganwg was of the same opinion, and cogent arguments for this tradition have been put forward by Rachel Bromwich and other academics.

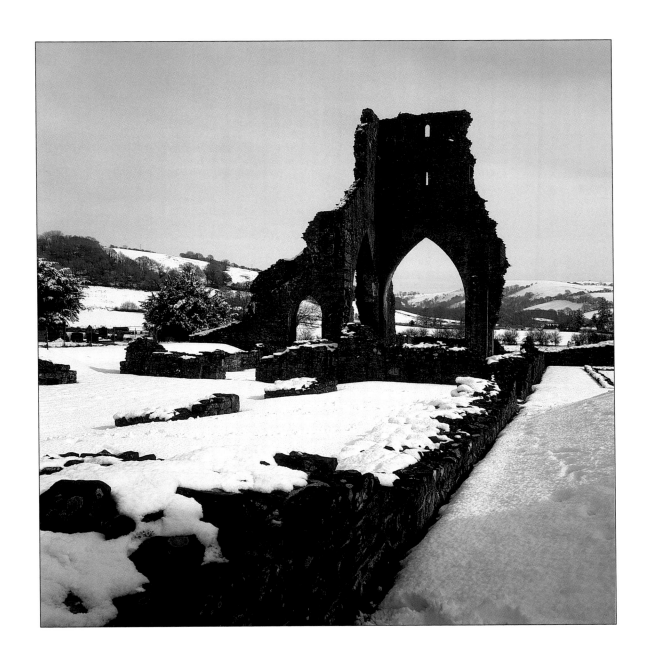

Maenorbŷr

'Of all the lands of Wales, the most beautiful and most attractive is that of Dyfed, and of Dyfed, Pembrokeshire; and of Pembrokeshire, the countryside around Maenorbŷr. It follows, therefore, that this place is the most lovely in all of Wales.' This is

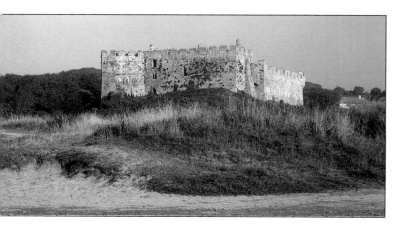

what Gerallt Gymro (Giraldus Cambrensis) wrote. He was born in Maenorbŷr (Manorbier) Castle, a grandson of Gerald de Windsor, a powerful Norman lord, and of Nest, the daughter of Rhys ap Tewdwr, the last king of the Southern region, who was killed in a battle against the Normans near Brecon. Gerallt was related to Lord Rhys, Prince of the South, and he wrote about Wales in the time of Rhys, siding sometimes with the Normans and sometimes with the Welsh.

Gerallt's first language was French, but he could understand Welsh. For some years he lectured through the medium of Latin at the University of Paris, and he also wrote in Latin. His two books about Wales are the best of the dozen he wrote. These strikingly interesting books are by far the best sources on life and history in Wales in the twelfth century. One of them gives an account of his journey through Wales with the Archbishop Baldwin, who tried to raise soldiers for the third crusade.

Gerallt's great ambition was to be bishop of St David's and archbishop of Wales. He stuck resolutely to this aim even though he was offered four other bishoprics including Bangor and Llandaf. He struggled bravely for five years, devoting himself completely to the Welsh campaign for an archbishop at St David's, equal in status to the archbishops of England and Ireland. He was nominated as bishop by the canonists of St David's, but the nomination was turned down by King John. He travelled to Rome three times to put his case to the Pope. No less a person than Llywelyn the Great prophesied that poets and historians would praise his bravery as long as Wales existed, and Gwenwynwyn, Prince of Powys, declared that there never was a battle 'so great and ferocious as his against the King and the Archbishop, when he withstood the whole might of England for the honour of Wales'.

Cydweli

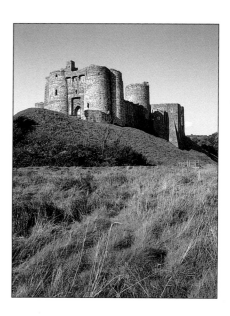

Wales was in a serious state of crisis at the start of the twelfth century. In the north the Normans had reached the extreme west, building castles at Môn, Meirionnydd, Bangor and Caernarfon. Gruffudd ap Cynan, the King of Gwynedd, redressed the balance there. In the south, after the murder of Rhys ap Tewdwr, the King of the South, in a battle near Brecon in 1093, the Normans swept as far as the west coast, erecting castles at Cardigan and Pembroke.

Most of the regions of the south were annexed, including the Southern Kingdom. When he was old enough to be a soldier, Gruffydd ap Rhys ap Tewdwr led the attacks in the south, not without success. Gwenllïan, daughter of Gruffudd ap Cynan, became his wife, and their family of brave sons all played a part in the campaign of the Welsh to regain their country. The turning point came when the men of Brecon, lead by Hywel ap Maredudd, won a great victory against the Normans near Cas Llwchwr (Lougher). Gruffydd ap Rhys went immediately to Gwynedd to beseech the help of Gruffudd ap Cynan in order to continue fighting. This is when Gwenllïan stepped, full of spirit, into the history of Wales. She decided that it behoved her, in the absence of her husband, to attack the Norman stronghold, the town and castle of Cydweli.

'She marched,' says Gerallt Gymro, 'like the queen of the Amazons and a second Pentesilea in leading her army.' With her were two of her sons, Morgan and Maelgwn, youths in their teens. She met in battle with the Normans led by Maurice de Londres, in the Gwendraeth Fach Valley, about a mile from Cydweli Castle. The place is known as Maes Gwenllïan to this day. The Welsh were defeated. Gwenllïan and Morgan, mother and son, were killed. Maelgwn was taken prisoner.

Gerallt Gymro says of the Welsh of that time, 'They focus their mind on defending their country and its freedom only; they fight for their country, they strive for freedom.' That is what Gwenllïan did. She fought for freedom; she gave her life for her country.

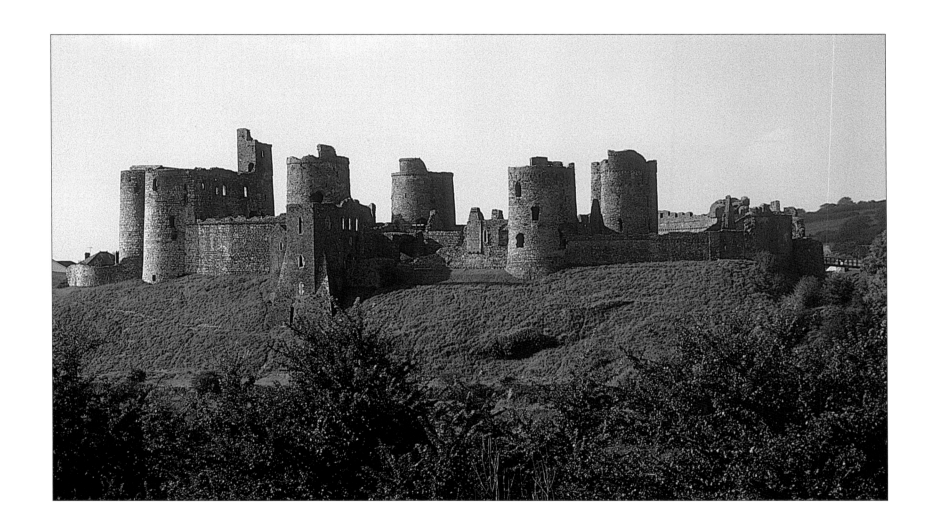

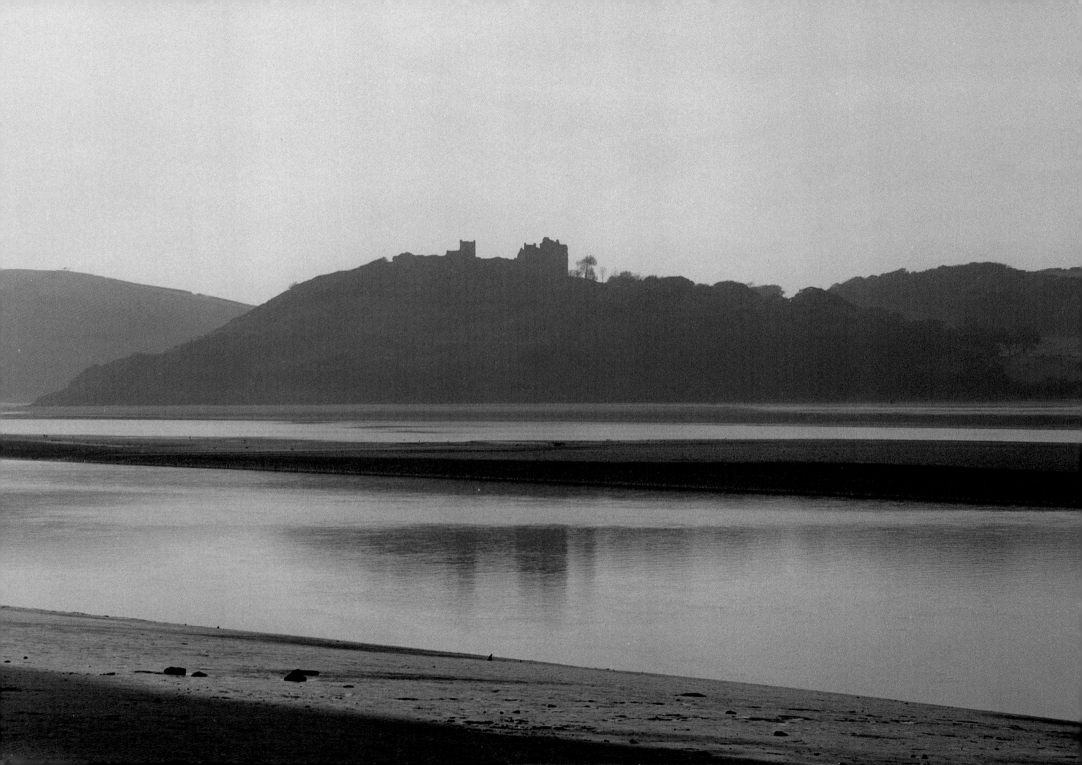

views from Ferryside

Llanilltud Fawr

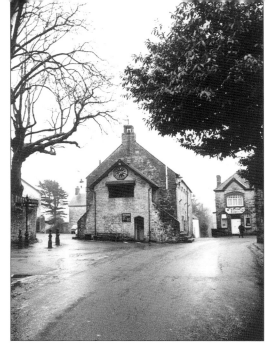
Town Hall

For a period at the end of the fifth century and the start of the sixth, the famous monastery of Llanilltud Fawr (Llantwit Major) in the Vale of Glamorgan was the main centre of Christianity in the Celtic countries. Certainly the monasteries of Llanilltud Fawr and Llancarfan contributed greatly to the early growth of the Celtic church. The starting point of this Christian, European missionary movement was the south-east and south-west of Wales. The Irish played a prominent part in the Celtic church, although Britons (Brythoniaid) were the chief leaders of Irish monasticism in the first century in the Age of the Saints.

As the Vale of Glamorgan is in that region of Wales where Roman influence had been heaviest, the education and Christianity of Abbot Illtud, the most important man connected with the monastery, were Roman. We know more about Illtud than we do most of the saints through the *Life of Samson*, written by one of his most famous disciples two generations

grave at Llanilltud Fawr graveyard

after his death, where we learn of the enormous scope of Illtud's learning. Samson had been an abbot in a monastery near Dublin and, like Paul Aurelin, who had also been a student of Illtud, his influence in Cornwall was vast. It was in Brittany, however, that he made his name, where he is known as Samson of Dôl.

Another famous disciple of Illtud was Maelgwn Gwynedd, the most powerful of the Welsh kings and the king-superior of the Britons. One of Maelgwn's co-disciples was Gildas, author of the Latin book *De Excidio Britannie*, the primary source of our information for this period. Gildas, a native of Strathclyde in Scotland, was a great influence on the Christianity of Ireland at a time when there was a great deal of travelling to and fro betweeen the Celtic countries. According to a *Life* written about him by a Breton monk he set up a monastery in Vannes, Brittany.

Illtud's Cross, Llanilltud Fawr

45

Glamorgan coast

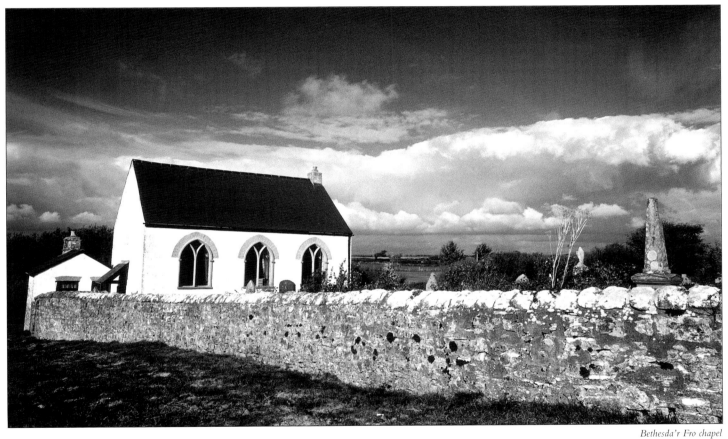

Bethesda'r Fro chapel

Cadog and Iolo Morganwg

The monastery of Cadog, the most learned of the saints of the sixth century, used to be in Llancarfan in the Vale of Glamorgan, eight miles from Llanilltud Fawr (Llantwit Major). About twelve centuries later Iolo Morganwg was born in the same parish; he was surely the strangest genius Wales has ever seen. Cadog was a contemporary of Maelgwn Gwynedd, the king-superior of the Britons, and Iolo a contemporary of the hymn writer, Williams Pantycelyn. Cadog quarrelled with Maelgwn, and Iolo detested the Methodism of Pantycelyn.

From his missionary monastery, Cadog was one of the main leaders of the great revival that filled Wales, Cornwall and Brittany in the post-Roman period with monasteries and churches. His influence extended to Ireland. Father Ryan, a historian of early Irish monasticism, maintained that this influence was the stimulant behind the intellectual movement in the monasteries of Ireland which had such a profound effect on Europe.

Iolo Morganwg, the extraordinary stonemason genius, was born less than two miles from the location of Cadog's monastery. This brilliant scholar and poet possessed more knowledge about the literature and history of Wales than anyone in his time. But a mental kink (the side effect perhaps of the laudanum he took all his life) led him to forge history and literature in order to prove the importance of Glamorgan in the Welsh tradition. The enormous scale of his learning can be seen in the *Iolo Manuscripts, Cyfrinach Beirdd Ynys*

Iolo Morganwg's memorial in Trefflemin church

Prydain (The Secret of the Bards of the Island of Britain) and *The Myvyrian Archaiology*. He was a founder of the Welsh Unitarians, and he wrote three thousand hymns. He established the Gorsedd of Bards and he succeeded in linking this to the eisteddfod movement – without him it is unlikely that the National Eisteddfod would exist. He was buried at Trefflemin (Flemingston) church, where a monument was erected to acknowledge his contribution to Welsh culture.

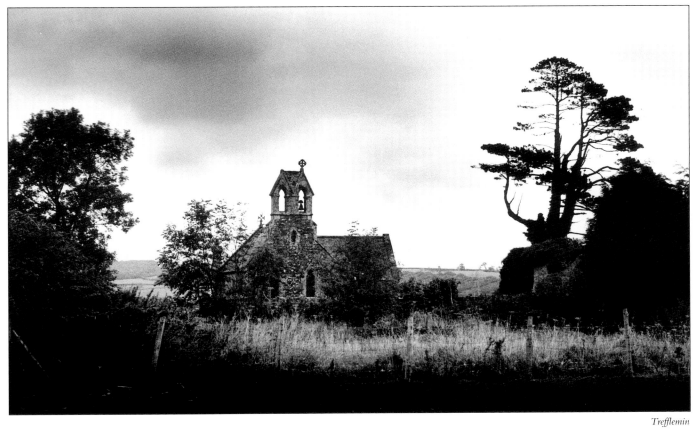

Trefflemin

Capel Gwladus

Gwladus is one of the amazingly large family of saints whose father was Brychan Brycheiniog. She is commemorated in Capel Gwladus (Gwladus' Chapel), Gelli-gaer. She became famous as the mother of St Cadog and we find her strange love story in the *Life of Cadog*. The history, which is full of unintentional comedy, was written by Lifris of Llancarfan at about the same time that

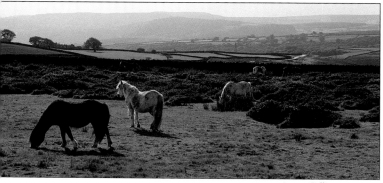

Rhygyfarch wrote the *Life of Dewi*. Her ardent lover was Gwynllyw, king of Glamorgan, who sent messengers to Brychan to ask for the beautiful, elegant Gwladus' hand in marriage, the *Life* says. Gwynllyw was beside himself with anger when Brychan refused. He sent three hundred soldiers to fetch her to his palace in Glamorgan.

Brychan remained stubborn and he formed an army to bring Gwladus back home. He pursued Gwynllyw, killing two hundred of his men. His army got as far as the boundary of Glamorgan, to a place called Bochriwcarn (Fochriw today). Gwynllyw was in trouble. Who happened to be there but King Arthur,

ponies on Gelli-gaer common

playing dice on the top of a hill with two of his knights, Cai and Bedwyr. Instead of going to help Gwladus and her sweetheart, Arthur took a fancy to her himself. 'He was filled with bad thoughts,' the *Life of Cadog* says, and quotes Arthur as saying, 'Know ye that I am vehemently inflamed with love towards the lady.' Cai and Bedwyr charged him to stop, for their duty, they declared, was to help those in distress. Arthur was persuaded. He and his knights set upon Brychan's army, driving them head over heels back to Breconshire.

Llancaiach Fawr

Fair Gwladus was brought to Gwynllyw's palace, and the *Life* says, 'King Gwynllyw united himself in lawful wedlock to the aforesaid daughter of Brychan, named Gwladus, who conceived, and wonderful to be mentioned… ' Cadog was born.

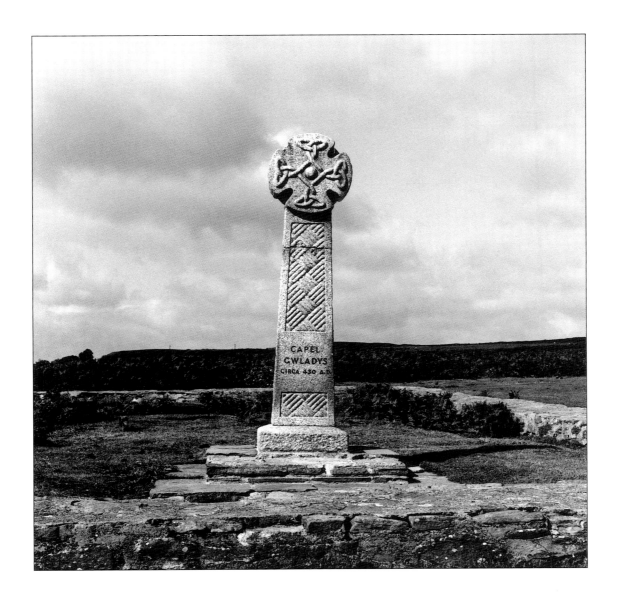

Pontypridd

Memorial for the James brothers

On the common above Pontypridd stands a great rocking stone. Even though it weighs almost ten tons it was said that at one time the touch of a child could make it rock. In the mid-nineteenth century the druids of Glamorgan held their festivals here, and the amazing Dr William Price, the prominent Chartist and the pioneer of cremation, used to hold his ceremonies as archdruid on the rocking stone.

In the Taf Valley, beneath the rocking stone, is the town of Pontypridd, where the Reverand William Edwards' famous bridge still stands, with its 140 foot long curve. Welsh was the language of the area when the bridge was erected in the mid-eighteenth century, and Welsh continued to be Pontypridd's language a century later when a company of poets, Clic y Bont (the Bridge Clique), met there. This is when Evan James went for a stroll one evening along the banks of the river Rhondda, which joins the river Taf in Pontypridd, and composed the words of *'Hen Wlad fy Nhadau'* (Land of my Fathers). He returned home and recited them to James, his harpist son, and he then composed the tune. It is fitting that two ordinary working men, a father and son, should have composed our national anthem.

Thereafter the old language was drowned by English education and a flood of English incomers. By the middle of the twentieth century a mere handful of children and young people spoke Welsh in Pontypridd and the vicinity. However, a national Welsh revival raised a nationwide awareness in thousands of people, and more and more non-Welsh-speaking parents began to insist on having a Welsh education for their children. At Pont Siôn Norton on the edge

Ynys Angharad Park

of Pontypridd a group of mothers, every one of them non-Welsh-speaking, took over the school in 1959 in order to compel the education authority to turn it into a Welsh-language school. Today forty percent of the children in the Rhydfelen area have their education through the medium of Welsh. Nothing more heartening is happening in Wales.

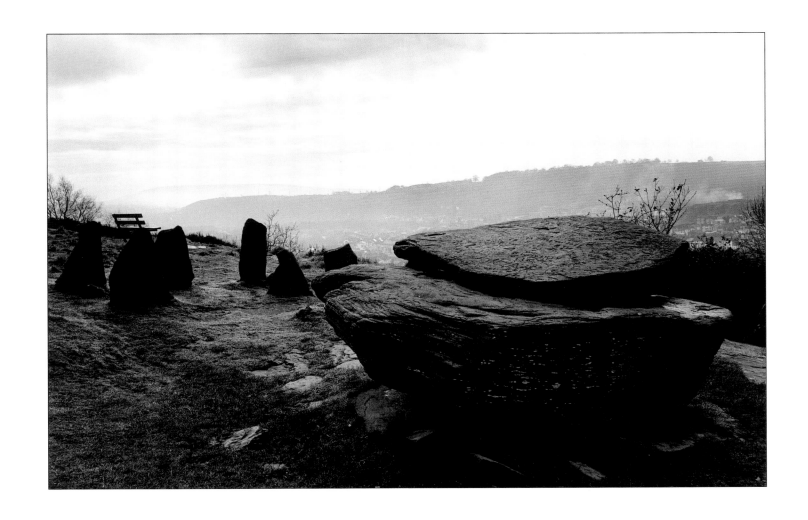

Cwm Rhondda

The image of the Virgin Mary at Pen-rhys (located on the mountain above the Rhondda Fach) used to draw thousands of pilgrims during the closing centuries of the Middle Ages. It was one of the main sacred places in Wales and England. It was considered by the leaders of the Protestants in London to be one of the most dangerous places where the Virgin Mary was

venerated. The poets created a greater body of work celebrating this shrine than any other.

Up to 1841 the population of the rural Rhondda Valley was only about five hundred. By 1924 it was a lively but turbulent mining community of 167,000. The work of the colliers was horribly hard and dangerous. 168 people were killed in an explosion in the Ferndale Pit in the Rhondda Fach in 1868. The dangers of the pits strengthened the loyalty of the workers to each other and to the labour unions. The unions found a very efficient and very Welsh leader in William Abraham (Mabon), an eisteddfod compere second to none. Welsh was the language of the community and industry in the Rhondda Valley of his day.

Mabon won a monthly holiday for the colliers, known as Mabon's Day. He also won fairer employment terms. He nurtured trade unionism in the Rhondda. A number of brilliant leaders came up from among the workers. The obvious strength of the region was the firm support of the women, a virtue that was brought to the fore in the 1985 strike.

Although some of the leaders began their public lives as members of the Nonconformist chapels, usually Welsh, during the first decade of the twentieth century the huge influx of in-migration and English education were beginning to make their deep mark on the language and the chapels. Nevertheless, even in this period, 64 percent of the population continued to speak Welsh. In the second half of the twentieth century Rhondda's national awareness increased. This resulted in a remarkable growth in the number of pupils attending the new Welsh-language schools. In the higher part of the Rhondda Fach as many as 28 percent of the children attend Welsh schools.

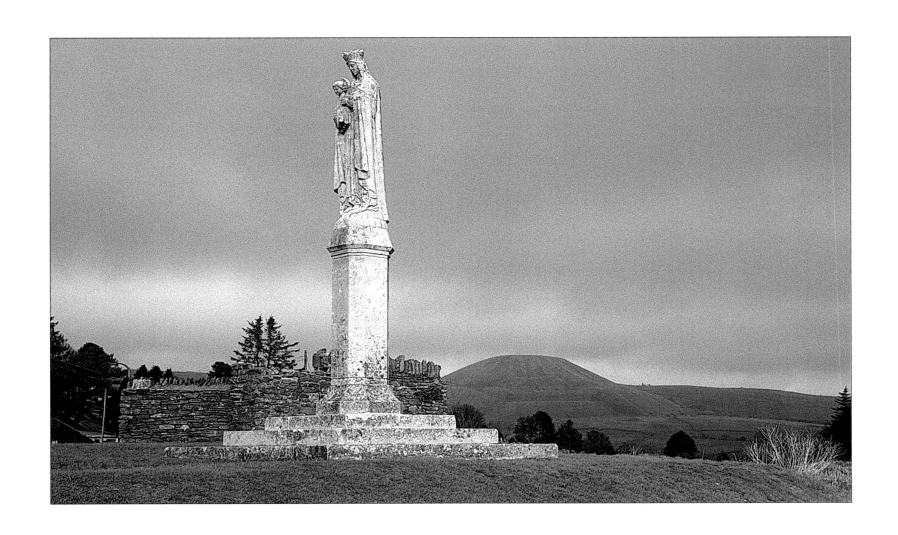

Merthyr Tudful

the old stables, Dowlais

Merthyr Tudful can claim to be the most interesting town in Wales. After the development of the iron and coal industries there over two hundred years ago it grew to be one of the biggest industrial towns in the world. During the 1830s eighty thousand people lived in its vicinity, and Welsh was the language of this huge population. Merthyr Tudful was the main cultural centre of Wales. The workers and their families filled the tens of Nonconformist chapels, and numerous intellectuals frequented the dozen or so cultural societies that usually met, as did the poets, in the pubs.

The citizens of Merthyr fought for social justice in an astonishing campaign in 1831. Led by Lewsyn yr Heliwr (Lewis the Hunter) thousands met on a mountain on the edge of the town to protest against the oppresion and suffering. After raising the Red Flag – for the first time in history – they marched to the town and beseiged the magistrates in the Castle Hotel. Eighty Scottish soldiers came from the military camp in Brecon to restore order. The townspeople attacked them and at least twenty four lives were lost and seventy people injured. In spite of that, the town remained in the hands of the workers for four days. During that period professional soldiers were overpowered twice. It was not until twelve hundred soldiers assembled around the town that the rebellion was quashed. Only one worker was hanged following the protest, and he was innocent. His name was Dic Penderyn. *'O Arglwydd, dyma gamwedd'* ('O Lord, this is an error') were his last words on the scaffold.

A generation after the rebellion Henry Richard of Tregaron, a man famous throughout Europe, was elected Member of Parliament. His speech in the House of Commons emphasised that he was a Welshman, a radical and a Welsh Nonconformist who stood for 'Wales and the worker'. He tried to fulfil the Chartists' policy, but it is as a pacifist that he made his name in Europe. The crowds that went to listen to him speak on a mountain would leave singing *'Hen Wlad fy Nhadau'*.

Another notable M.P. for Merthyr was Keir Hardie, founder and leader of the Labour Party, who was also a Celt and a Christian, and one who backed self rule for Wales; the Labour Party itself at the time was strongly in favour of self-government for Wales.

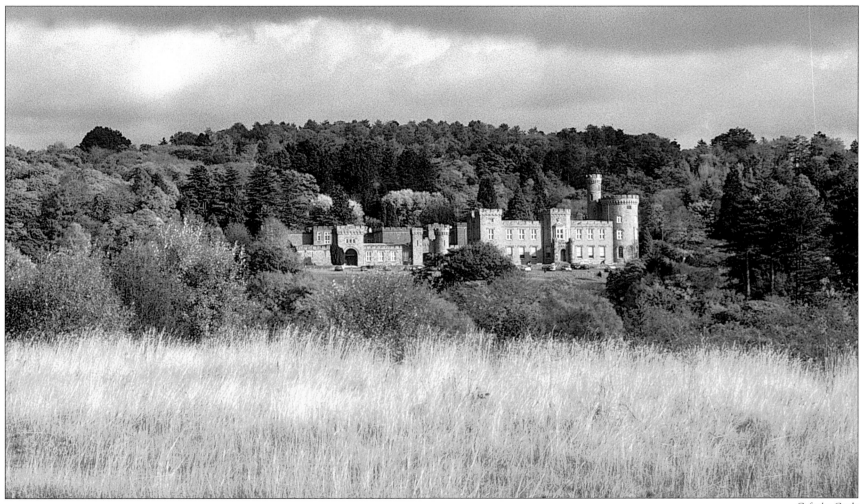

Cyfartha Castle

Rhaglan

It seems strange now to think of the grand welcome that Welsh poets and musicians could expect in Rhaglan Castle on the English border with Gwent. Sir Wiliam ap Thomas and Gwladys his wife (a daughter of Dafydd Gam of Brecon who was knighted on the battlefield at Agincourt) kept an open house there. As did their son William Herbert. The poets Guto'r Glyn and Lewys Glyn Cothi were regular visitors to Rhaglan, and the scholar D J Bowen suggests that it was in Rhaglan Castle that the poetic competition between Siôn Cent and Rhys Goch Eryri took place. Though Herbert was one of Edward IV's ministers it is said that his Welsh was more fluent than his English.

William Herbert was the Welsh leader of the Yorkists in the Wars of the Roses, a war that was fought to a large extent between Welsh armies. Jasper Tudor, another patron of the poets, led the Lancastrians. They were both in turn considered Welsh national leaders by the bards. The bards called upon Herbert, who was enobled as the Earl of Pembroke, to unite Wales and end Engish rule. If he had done this, Guto'r Glyn said in a passionate appeal to Herbert after he captured Harlech Castle, the Welsh would have backed him.

Na'd f'arglwydd, swydd i un Sais,	(Say no, my lord, to privilege any Englishman,
Na'i bardwn i un bwrdais.	Nor give him pardon in any town
Dwg Forgannwg a Gwynedd,	Bring Glamorgan and Gwynedd together,
Gwna'n un o Gonwy i Nedd.	Make us united from Conway to Neath.)

When Herbert was executed after the battle of Banbury fourteen elegies were written for him. Two and a half thousand Welshmen were killed in that battle, including 168 men of distinction. One of them was a half brother to William Herbert, Tomos ap Rhosier of Hergest, a generous patron of the poets. It was in Hergest, a mansion in a part of Hereford that used to be completely Welsh-speaking, that *Llyfr Coch Hergest (The Red Book of Hergest),* one of the most important Welsh manuscripts of the Middle Ages, was at one time kept.

Caerllion

It could be boasted, with reason, that Wales is the sole inheritor of Roman civilisation in Britain. The thousand Latin words in the Welsh language testify to Rome's impact upon the language and culture of our country. However, our forefathers were not easily subjugated by the Roman legions. In the fighting, which lasted a whole generation, the legions suffered heavy losses before overcoming the people that would, in five centuries' time, call themselves the Cymry.

'Welsh' was the name that the Germans gave to people under Roman rulership. It is significant that two of the three legions in Britain settled on the Welsh border, one in Chester and the other at Caerllion (Caerleon) in the land of the Silurians (a tribe of Celts that had been very stubborn in their opposition to Rome).

To entertain the thousands of soldiers at Caerllion, as well as the inhabitants of the area, an amphitheatre was built, which held six thousand. The only similar one in Wales is in Caerfyrddin (Carmarthen). Close to the fortress was the city of the legions where the Christians, Aaron and Julian, were martyred, in about 300 AD, during the persecution of the Emperor Diolcetian.

It was not these Christian martyrs, however, that made Caerllion famous, but rather a book by an author of Breton blood, Geoffrey of Monmouth, in the twelfth century, namely *Historia Regum Britanniae*. This book brought King Arthur to prominence and as a result Arthurian legends became well-known throughout Europe and the world. Geoffrey's home was in Gwent, not far from Caerllion, and he located Arthur's court in Caerllion. This is where Arthur gathered his knights at the Round Table. A generation later, Gerallt Gymro (Giraldus Cambrensis) described Caerllion, 'One can still see here the remains of the old glory of the past, palaces of immeasurable size… ' Perhaps these glorious ruins touched the patriot that lurked in Geoffrey's heart and compelled him to place Camelot in Caerllion.

Capel-y-ffin

Llanthony Abbey ruins

Capel-y-ffin rests amid the beauty of the Black Mountain of Gwent and Breconshire. Father Ignatius attempted to create a Benedictine monastery there from 1870 onwards, on land that belonged to the Friary of Caldey Island. The statue of the Virgin Mary in the picture can be seen outside the ruins of the monastery's church.

Father Ignatius, who came from a well-known Gwent family, hoped to revive the monasticism of the Church of England. He had great influence as one of the strongest preachers of the end of the nineteenth century, but despite travelling far to raise money to establish the monastery he did not obtain sufficent funds to complete the work. He was buried near the altar of the ruined church.

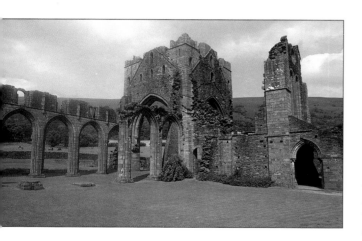

Father Ignatius had much to say about Wales and her Nonconformity, and he tried to learn Welsh. When he was president of the day at the National Eisteddfod at Brecon in 1889, he gave high praise to the Methodist revivalists and to the Sunday Schools of the Nonconformists. The Welsh language was still strong enough in Brecon just over a century ago to hold a fine National Eisteddfod. In 1898 Hugh Thomas of *The Herald* could claim that the ordinary language of Brecon was, 'as good as any Welsh to be had in Wales'.

Among those who came to live in the monastery buildings of Father Ignatius after his day was Eric Gill the artist, sculptor and designer. He was joined for some years by David Jones, the writer, poet and painter, who fell in love with Petra, Eric Gill's eldest daughter. His masterpieces were *Anathémata* and *In Parenthesis,* an elegy in the style of *Y Gododdin,* based on his experience in the First World War with the Royal Welsh Fusiliers. Welsh and Celtic myths, especially the Arthurian ones, are prominent in the work of David Jones, an artist said by critics to express the Welsh literary tradition in paint.

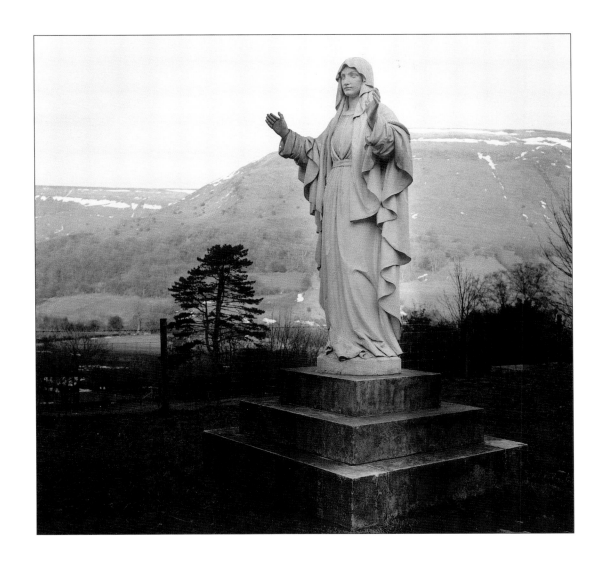

Capel Anwes, Capel-y-ffin

Lady Llanofer, Gwent

Of all the people connected with the language and culture of Wales few are more colourful than Augusta Hall, Lady Llanofer, and the group of women and men that surrounded her. These clever and cultured ladies came from the gentry of Gwent, Brecon and Glamorgan, and most had mastered the Welsh language. Among them was Jane Williams, or Ysgafell; Lady Greenly, also

details from Lady Llanofer's tombstone

known as Llwydlas, who took a great interest in the folk tunes of Wales; Jane Williams, Aberpegwm, who published a very valuable volume of tunes, *The Ancient National Airs of Gwent and Morgannwg*; and the noted Charlotte Guest, who translated the *Mabinogion*. Gwenynen Gwent (The Bee of Gwent, Lady Llanofer's bardic name) made a great effort to nurture women's interest in the life, language and culture of Wales. She was the patron of *Y Gymraes (The Welshwoman)*, the first magazine for women in Welsh.

She worked unstintingly, with the help of her husband Benjamin, to promote Welsh folk life, language and culture, especially music, dance, food and the Welsh costume. Welsh was the language of all those who worked for her on her vast estate. She set up a factory making *telynau teires* (triple harps), and she persuaded her wealthy friends to give them as presents. Characteristically the Seiriol Harpist taught the harp at Llanofer, and he was one of a remarkable family of famous harpists from Llannerch-y-medd that had often played for the royal family.

Gwenynen Gwent promoted all aspects of the great work of Carnhuanawc (Thomas Price), mainly by inviting gentry and celebrities to the famous Abergavenny Eisteddfod which was held every year for fifteen years. There were often as many as four hundred carriages full of visitors in the colourful procession to the Eisteddfod. Also under the direction of Carnhuanawc, she and her husband purchased the precious manuscripts of Iolo Morganwg, known thereafter as the *Llanofer Manuscripts*.

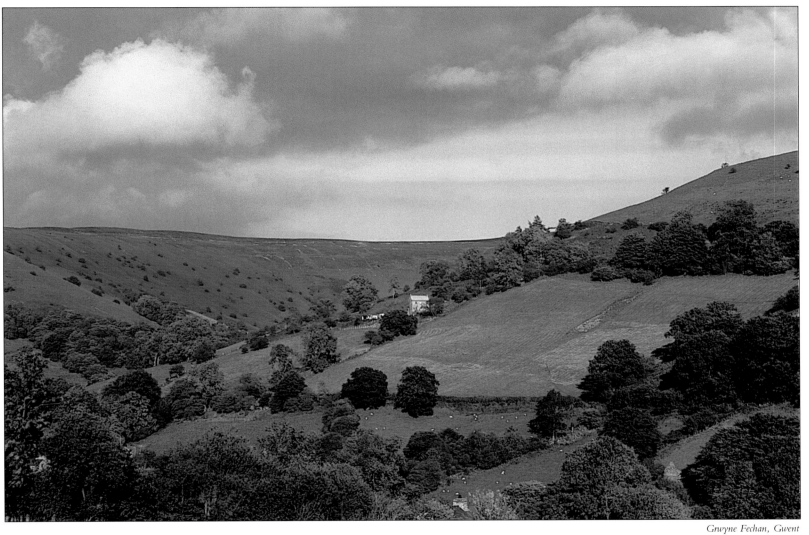

Grwyne Fechan, Gwent

Carnhuanawc

Tretŵr house and gardens

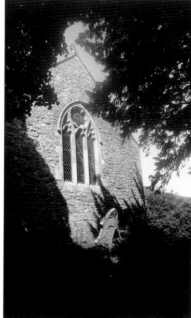
Llanfihangel Brynpabuan church

Carnhuanawc (Thomas Price), one of the most important Welshmen of the nineteenth century, was born at Llanfihangel Brynpabuan in Breconshire. There was an emphasis on the harp and folk songs in the home of the young Thomas, and he continued to be interested in the harp for the rest of his life. He founded the Welsh Minstrelsy Society. Carnhuanawc was a clergyman in the Church of England. For almost the last twenty five years of his life he was vicar at Llanfihangel Cwm Du, a few miles from the English border, when that neighbourhood was still Welsh-speaking. The curacy of Tretŵr (Tretower) and Merthyr Ishw (Partrishow) was later added to his care.

His interest in Brittany was awakened when he befriended Bretons in the French Navy who were prisoners in Brecon during the Napoleonic wars. He was very interested in all the Celtic countries, and their languages and antiquities. He was one of the foremost scholars of his day. He helped to set up the Welsh Manuscripts Society, he edited the *Iolo Manuscripts*; he also published numerous academic studies. He insisted on publishing his masterpiece *Hanes Cymru* (Welsh History) in Welsh, a book he wrote at his home in Llanfihangel Cwm Du. At his own cost he maintained a Welsh school near his home.

With astonishing energy, Carnhuanawc inspired the interest of a host of noblemen in Wales and in its history and culture. He was primarily responsible for the success of Cymreigyddion y Fenni (The Welsh Enthusiasts of Abergavenny) and for a series of wonderful eisteddfods which that society organised annually for almost two decades. His inspired eisteddfod speeches deeply influenced the large number of gentry and others that supported the Fenni eisteddfods. He took every opportunity to praise the folk of Wales, as in the following statement in the Welshpool Eisteddfod, which is typical of him, 'Perhaps it would be difficult to point out any other country in the world in which the peasantry and lower classes feel such an interest in literary and intellectual pursuits as the people of Wales do.' It is hardly any wonder that the *Blue Books* attacked him personally.

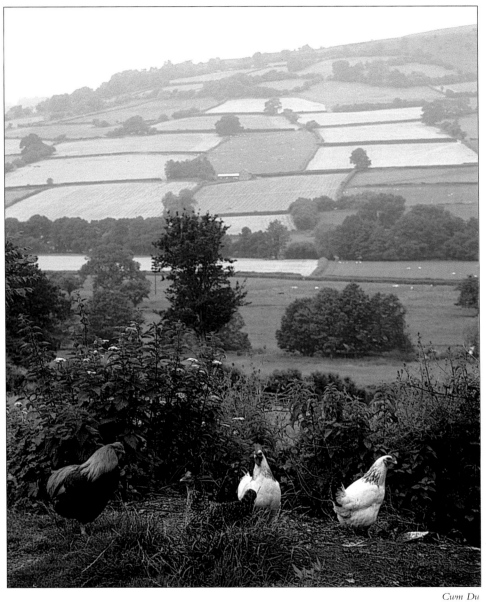

Cwm Du

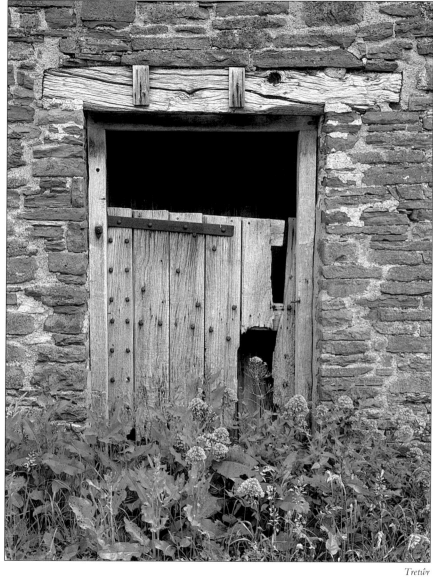

Tretŵr

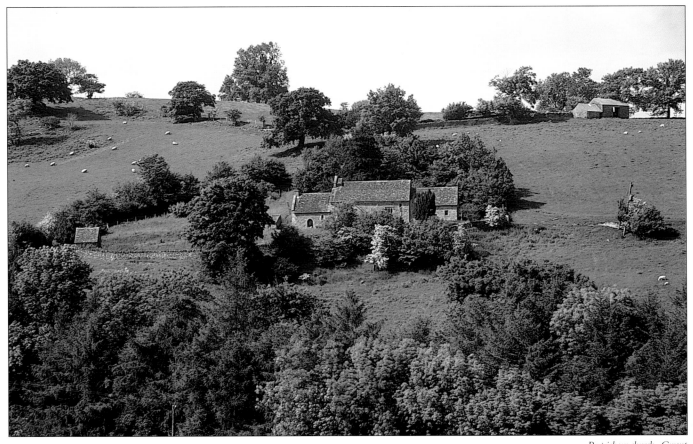

Partrishow church, Gwent

Dinas Emrys

Near Beddgelert in the Gwynant Valley lie the remains of an old fortress on top of a rocky hill. Its name is Dinas Emrys. It is believed that the fort is named after Emrys Wledig, Ambrosius Aurelianus; but this explanation was confused with the tale of Ambrosius Merlin, namely the Myrddin or Merlin of Caerfyrddin (Carmarthen). Emrys Wledig was the historical military leader who won, according to legend, a number of victories against the Britons' campaign on behalf of the Saxons in the first half of the fifth century. He was also an opponent of Gwrtheyrn, king-superior of the Britons – Emrys representing the Roman tradition and Gwrtheyrn the native tradition. He possibly drove Gwrtheyrn to Gwynedd.

In his *Historia Brittonum* dating from the beginning of the ninth century, Nennius tells the story of the battle between the red dragon and the white dragon at Dinas Emrys – the red dragon symbolising the Welsh and the white symbolising the Saxon invaders. Nennius relates the attempt of Gwrtheyrn to build a fortress above the Gwynant Valley, thwarted time after time by collapsing foundations. He is advised by a wise man to pour the blood of a boy 'with no father' over the foundations. He finds the boy in Caerfyrddin, a boy called Ambrosius, Emrys in Welsh. This unusual boy tells Gwrtheyrn and his wise men that there is a lake beneath the base of the castle and it is the war in the lake between the red dragon and the white dragon that keeps unsettling the fort's foundations. He predicts a victory for the red dragon in the centuries to come.

Nennius also gives us the history of Arthur as a military leader and notes his twelve victories. And from Nennius we get the tale of the invitation Gwrtheyrn extended to Hengist of Mersa and to the Germans to come to Britain. The legends of how Gwrtheyrn fell in love with Alys Rhonwen, Hengist's daughter, and the Treason of the Long Knives, when three hundred Britons were murdered by the English at a feast, are also tales told by Nennius.

Abergwyngregyn

The stream shown in the picture is at Abergwyngregyn, near Arllechwedd. This brook runs into the River Menai past Garth Celyn where the manor of the royal family of Gwynedd stood in the thirteenth century. It is highly probable that the main home of the princes Llywelyn the Great, Dafydd and Llywelyn the Second (the Last Prince of Wales) was located where the old house of Pen-y-bryn stands.

For fifteen of the forty-six years of the reign of Llywelyn the Great his great arch-enemy was John, King of England. The relationship improved for a while when Llywelyn married the King's daughter, Joan, 'Siwan' in the drama of that name by Saunders Lewis. In the senate of

Pen-y-bryn

Aberdyfi 1216, Llywelyn demonstrated his diplomatic skill when he succeeded in giving the independent and divided Wales an administrative system which remained in place throughout the remaining quarter century of his life. He also made an agreement at Ystrad Fflur with the princes of Wales to acknowledge his son Dafydd as his heir. But the princely line was shattered with the premature death of Dafydd.

Llywelyn the Great's grandson, Llywelyn ap Gruffudd, managed to draw the principality together and to expand it. In 1267, half a century after the Aberdyfi senate, he was recognised by England as the Prince of Wales. But Edward I ascended the throne fifteen years later determined to reduce the size of the principality of Wales and then destroy it. His chance came in the spring of 1282, with the rebellion of Dafydd, Llywelyn's brother. A truce was announced at the end of the autumn. But the Norman-English terms offered were completely unacceptable to Llywelyn. He responded with a dignified declaration that appealed to the long history of the Welsh, insisting that they were fighting for more than Gwynedd alone. They were fighting for the rights of all the people of Wales; they were battling for a nation. Better for them to die, he said, than to live under the oppression of the English.

Weeks after these discussions Llywelyn lay dead at Cilmeri. Six months later Prince Dafydd was delivered to the hands of the English on the mountain that rises above Garth Celyn.

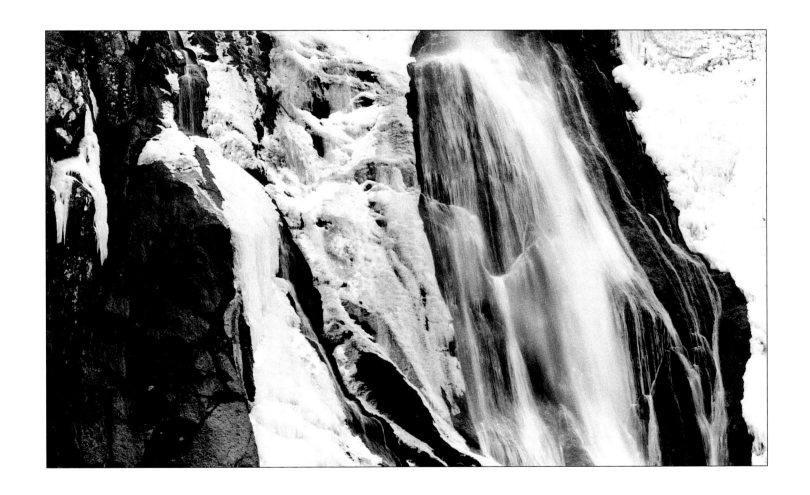

Y Fenai

The greatest act of treason on the part of the Romans in Wales was the murder of the druids on the banks of the Menai – a villainy comparable with the massacre of the monks of Bangor Is-coed (Bangor-on-Dee) by the Northumbrian army six centuries later. Tacitus recorded the former event and Bede the latter.

According to Nora Chadwick the druids were the intelligentsia of the Celts; they were their philosophers, their teachers, their judges and their priests. They trained the young and that education sometimes lasted twenty years. Julius Caesar and other hostile Romans painted a derisive picture of them because they hated the moral support the druids gave to the

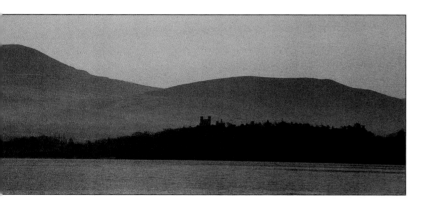

opponents of Rome. That opposition led to the slaughter at Môn in 61 AD, a generation after the crucifixion of Christ.

The Roman army saw a terrible sight beyond the Menai, says Tacitus. The British soldiers stood on the shores of Ynys Môn (Anglesey), 'like a forest of weapons', and behind them the druids raised their heads to the heavens, bellowing curses. But the Romans crossed the river on rafts or on the backs of horses, determined to wipe out all the Britons, soldiers and druids alike, in a ferocious attack.

Twelve centuries later, there was another battle on the banks of the Menai, during the final weeks of the last great war between the Welsh and the Normans. King Edward sent a large army, under the leadership of Luke de Tany, the governor of Gascony, to invade Ynys Môn. They had agreed a truce in November, but de Tany decided to take a shocking advantage and attack the Welsh on the mainland. He prepared a bridge of ships, built for the purpose, and when the river ebbed he crossed. But the Welsh repelled his army, winning a sweeping victory at Moel-y-Don. Weeks later Welsh independence came to an end when Llywelyn was assassinated at Cilmeri.

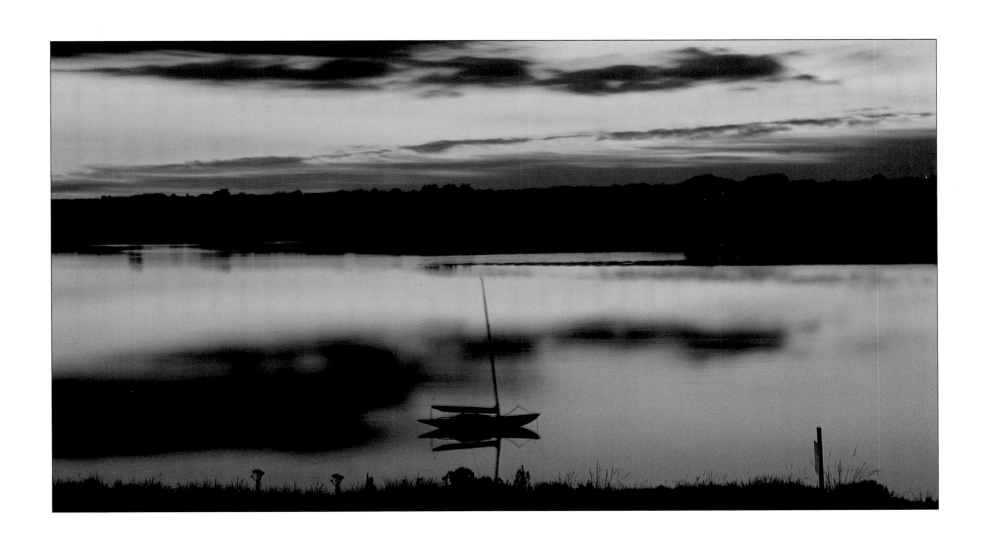

Sycharth

In Iolo Goch's poem to Sycharth, the court of Owain Glyndŵr, we have the loveliest picture from the Middle Ages of a Welsh home. The poem describes the beauty of the house, which had a tiled roof and a belfry and stood at the top of a hill in a civilised and handsome setting. It describes the stables, the mill and the dovecote; the orchard, the vineyard and the fish

pond; the deer park, the meadows and the cornfields, and above all, the welcome given there. A gracious hospitality flourished within, organised by Glyndŵr's wife, Marged, the daughter of the judge Sir David Hanmer.

At the Glyndŵr family's chief fortress in Glyndyfrdwy, in the region of Dinas Brân Castle, Owain was declared Prince of Wales by his followers on 16 September 1400. He was formally crowned four years later in the senate at Machynlleth. By that time there was an established Welsh state with a civil and diplomatic service, a treasury and a legal system, a Church recognised by the Avignon Pope, an armed force and a navy, a parliament and a prince – the last Welsh Prince of Wales. But the English burnt Sycharth to the ground.

The aim of the War of Independence, Glyndŵr said, was 'to liberate the people of Wales from the captivity of our English enemies who have oppressed us and our ancestors for a long time'. The struggle continued for ten years, and smouldered for another five. Adam of Usk said that Glyndŵr could call upon 30,000 men to fight for him. The population of the whole of Wales was about 200,000.

But the power of England proved too much. In the last battle in 1410 three of Owain's captains were taken prisoner, Rhys Ddu, Philip Scudamore and Rhys Tudur; they were executed as English traitors. Guerrilla warfare continued. There is no word of Glyndŵr after 1415. 'A great many say,' a Welsh chronicler states, 'that he died, the prophets say that is not so.'

Bryn-glas

Owain Glyndŵr was declared Prince of Wales by his supporters at about the date now known as Glyndŵr's Day, 16 September 1400. The aims of his war were national from the start, and his first warring actions destroyed towns in the north-east of Wales. Eighty of these towns were built around English castles, each one a centre of the English people and English tongue, and were created with the aim of persecuting the Welsh. Triumphs of his campaign include the capture of Earl Grey, his arch-enemy, and the collection of a ransom for his release, and the holding of Conway Castle by the Tudors of Penmynydd.

The turning point in the war, from the point of view of the English government, was Glyndŵr's successes at Hyddgen on the slopes of Pumlumon in the summer of 1401 and at Bryn-glas in the summer of 1402. The bloody victory of Bryn-glas near Trefyclawdd (Knighton), on the edge of the boundary with England, was the one that shocked the English most. In

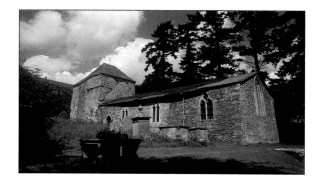

every English army there would have been a large company of Welsh archers – that was their way of earning a living. At Bryn-glas the Welsh archers turned against the English army in support of their compatriots, and from then on the English realised that they were fighting a war where the national freedom of Wales was at stake.

The importance of the Bryn-glas triumph was increased by the capture of the leader of the English army, Edward Mortimer. Mortimer was the most significant of the Marcher lords, and he had at least as good a claim to the crown of England as Henry VI himself. The King refused to pay a ransom for his release. As a result, Mortimer joined Glyndŵr and married his daughter, Catrin, of whom Shakespeare wrote, 'Her tongue makes Welsh as sweet as ditties highly penned.' Mortimer ordered his followers also to support Glyndŵr, who was by now in control of Gwynedd and Powys and many other parts of Wales.

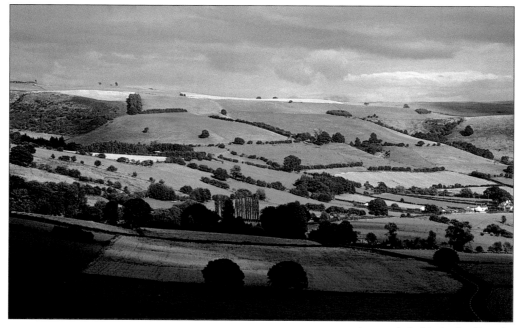

view towards the Marches from Bryn-glas

Meini Cyfamod Glyndŵr, Hyddgen, Pumlumon

Trwyn y Gogarth

Llety'r Filiast, Orme's Head

The English name for Trwyn y Gogarth, the peninsula near Llandudno, is Orme's Head. It was named after Gorm or Orme, the chief of the Northmen (the Black Pagans of the *Lives*) in the ninth century. Gorm was a man to be feared in western Europe, where the Northmen wreaked havoc from the beginning of the ninth century until the eleventh. They also took over huge swathes of England, Ireland and Scotland.

The leader of the Welsh opposition to the Black Pagans during the reign of Gorm was Rhodri Mawr, the greatest of the Welsh kings in the opinion of Nora Chadwick. There is reason to believe that Rhodri united Gwynedd, Powys and the kingdom of the South under one government peacefully. Evidence shows that he promoted culture, scholarship and art, a characteristic that he inherited from his father, Merfyn Frych, who held a cultured court in Gwynedd. Learned Irishmen stayed there on their way to the court of Charles the Bald, the son of Charlemagne. During the life of Merfyn, Nennius wrote about the history of Wales and the *Annales Cambriae* began to be recorded. The poetry of Llywarch Hen was composed during the life of Rhodri – work which is considered to be one of the greatest achievements of our literature.

However, Rhodri had to spend most of his life as a warrior fighting on two fronts. He defended his country against the attacks of the Northmen from the western sea, as well as the English attacks by land from the east. Rhodri gained his best triumph against the Northmen in a battle in 856, when Gorm their chieftain was killed. This was celebrated on the continent, where Gorm had caused so much damage, and a song of praise was written for Rhodri in Latin by Sedelius Scottus, an Irish bard and a scholar belonging to the court of Charles the Bald.

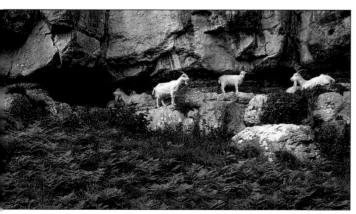

goats on Orme's Head

Rhodri also had important victories defending Powys against the English. But it was the English who killed him in battle, twenty years after his success over Gorm.

Cwm-hir Abbey

Llywelyn's grave

One good thing that came out of the two centuries of intermittent fighting against the Normans under a succession of powerful princes, was the deepening of the Welsh consciousness, which became strong enough to maintain a national identity against the enormous pressures from England.

This Welsh awareness reaches its zenith during the reign of Llywelyn the Second. His aim was to unite Wales and create an independent principality. He succeeded in forcing the English government to acknowledge him as Prince of Wales in the Contract of Montgomery 1267 – a contract confirmed by the authority of the Pope. But then in 1272 the non-English-speaking Edward ascended the throne, the mightiest of English kings, with his mind set on gaining imperialist control over Wales and Scotland. He achieved his goal in Wales and he almost succeeded in Scotland.

The final war was caused by the rebellion of Dafydd, Llywelyn's brother, in March 1282. Edward drew heavily on the ample resources of his empire. Although the Welsh scored a success in the battle of Moel-y-Don in November, Llywelyn was forced to look for new help. He was doing just that probably in the Buellt area in December when he was killed near the banks of the Irfon. His head was cut off and sent first to King Edward and then to London, where it was carried through the city to the delight of the crowds. What happened to it? The skull of the Last Prince could be under the foundations of a shop, bank or hotel in the capital of England.

We know what happened to his body. It received a more dignified fate than his brother Dafydd's body, which was quartered and divided between four towns in England. Llywelyn's corpse was taken by the White Brothers over the Radnorshire moors to be buried in the Cistercian monastery of Cwm-hir. It is proper that the remains of the great leader were laid to rest in the holy ground of an abbey belonging to the order which had been most faithful to his country.

Cilmeri

Edw River, Aberedw

Castell y Bere

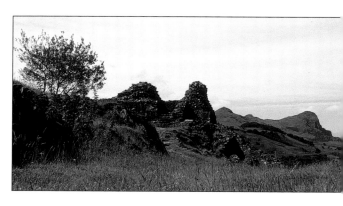

Castell y Bere was built by Llywelyn the Great to protect his hold on the south of Gwynedd. It stands at a strategic point of defence in the enchanting landscape between the western slopes of Cader Idris and Dysynni Valley. This is where Marion Eames, in her novel *Y Gaeaf sydd Unig (The Winter is Lonely),* depicts Eleanor, wife of prince Llywelyn ap Gruffudd, months only before her death, giving birth to her daughter Gwenllïan. The last battle of Llywelyn was inspired by the vision and response of his council to the terms set out by Edward I, namely that they refused 'to pay homage to any stranger, being completely unfamiliar with his language, his way of life and his laws'.

After the tragedy of Cilmeri, Dafydd, Llywelyn's brother, fought on for a further six months, laying claim to the title of Prince of Wales. The struggle of the Welshmen of Gwynedd was known thereafter as 'Dafydd's War'.

After they had defeated the kings of the southern region, the Norman army, which included thousands of Englishmen,

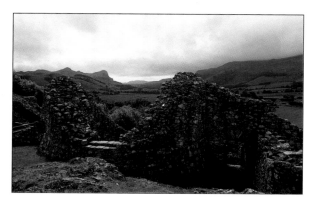

Saxons and Basques, moved up from the south. Another of their armies crossed over from Môn to capture Caernarfon and Harlech. Dolwyddelan Castle fell six weeks after Llywelyn's death, under attacks from an army that had travelled from Rhuddlan to the Conwy Valley.

Apparently Dafydd hoped to make his last stand in Castell y Bere, but as three thousand soldiers approached in two armies, he fled. He withstood the garrison for twelve days before being forced to yield at the end of April. Castell y Bere was the last castle of Wales to oppose a royal English army.

Dafydd still tried to act as a prince from his base in Eryri (Snowdonia). Among the faithful advisers around him were Hywel ap Rhys Gryg of the Dinefwr family and Goronwy ap Heulin, Llywelyn's steward. However, Dafydd was caught in the mountains on the twenty eighth of June, and on the third of October he suffered a horrible death in Shrewsbury as a traitor to England. The year was 1283, nine centuries after the departure of Macsen Wledig.

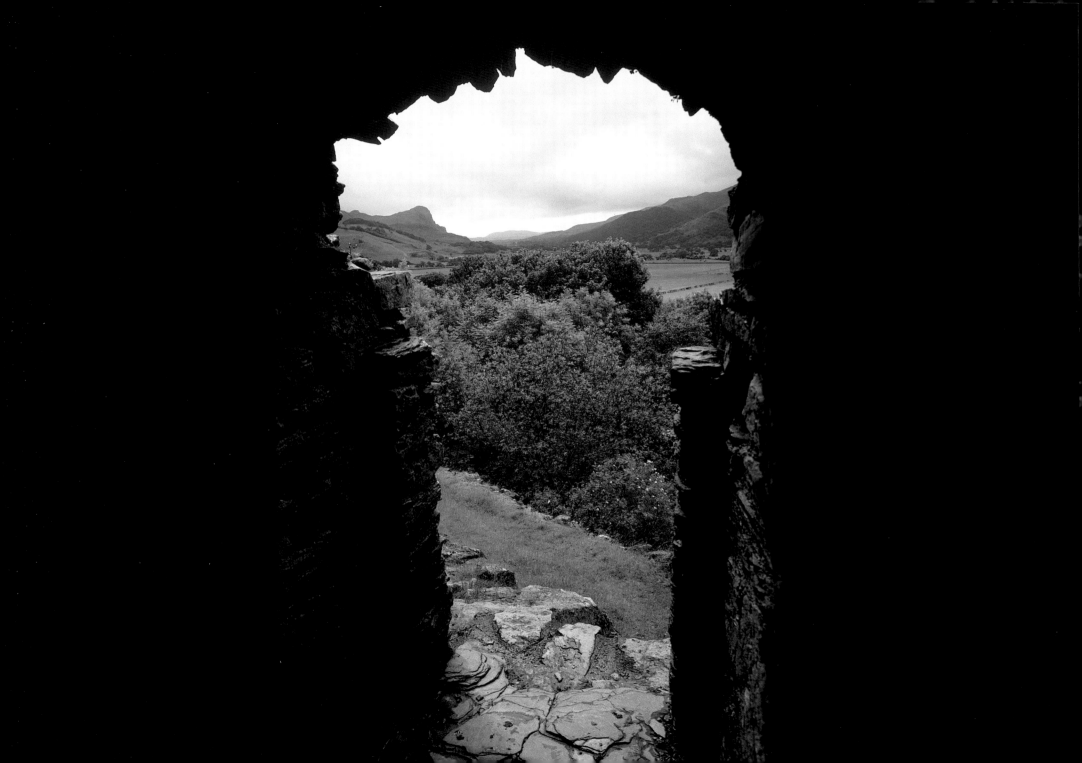

Tywi Uchaf

One example of the arrogant attitude of the British establishment towards Wales in the mid-twentieth century, was the decision of the Forestry Commission to plant trees on a million and a quarter acres of Welsh land. Plaid Cymru organised a strong campaign to oppose the plan, which was to start with the compulsory purchase of forty thousand acres of land around Tywi Uchaf (Upper Tywi Valley), above Rhandir-mwyn. The biggest event in the campaign was the great rally of 1949, which was held at a strikingly beautiful spot about three miles north-west of Rhandir-mwyn.

In spite of the narrowness of the route, about a thousand people managed to reach the enchanting location, a flat piece of land facing the lovely Doethie waterfall, gushing over the rocks to meet the Tywi, a sheer drop of hundreds of feet below the

crowd. Above the wooded hill, where the Doethie flowed over the rocky ridge, the cave of Twm Siôn Cati could be seen.

One of the speakers at the rally was Jennie Eirian, a beautiful woman unequalled in Wales as a public speaker. As she delivered her eloquent speech an old bachelor farmer from Tregaron interrupted her, shouting,

'Are you married?'

'I am,' answered Jennie.

'Oh damn, otherwise I'd have thrown my hat in!' said the farmer.

The Forestry Commission was defeated by the campaign.

two views of the Tywi Valley

Llyn y Fan Fach

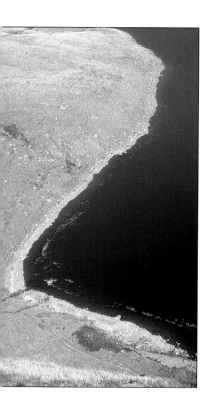

There is hardly a richer Welsh legend than the story of the maiden from Llyn y Fan Fach, with its distant memories of the terrifying coming of iron, of the days when people lived among the rocks, and of old traditional Welsh breeds of cattle and oxen.

A boy from Blaen Sawdde was standing on the shores of the lake herding his widowed mother's animals when he saw a beautiful maiden sitting on the surface of the water, combing her hair. He offered her a piece of bread and cheese. She rejected it, saying before disappearing beneath the water,

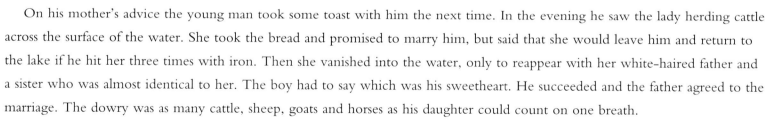

Cras dy fara,	(Go bake your bread,
Nid hawdd fy nala.	Of me you'll never get ahead.)

The lad told his mother what had happened. She advised him to take her some dough the next day. After he waited for a long time she appeared again, and the youth presented her with the dough and expressed his love for her. For the second time she refused him, saying with a smile before going under water,

Llaith dy fara,	(Soft is your bread,
Ti ni chara.	You're not my belovéd.)

On his mother's advice the young man took some toast with him the next time. In the evening he saw the lady herding cattle across the surface of the water. She took the bread and promised to marry him, but said that she would leave him and return to the lake if he hit her three times with iron. Then she vanished into the water, only to reappear with her white-haired father and a sister who was almost identical to her. The boy had to say which was his sweetheart. He succeeded and the father agreed to the marriage. The dowry was as many cattle, sheep, goats and horses as his daughter could count on one breath.

They lived at Esgair Llaethdy, Myddfai, and three sons were born to them. But tragically the story continued and told how the three accidental blows with iron made her return to the lake, calling the animals by name to follow her. She had taught the craft of medicine to Rhiwallon, the eldest son. His sons became *Meddygon Myddfai* (the Physicians of Myddfai) whose medicinal recipes are found in a manuscript in the National Library of Wales.

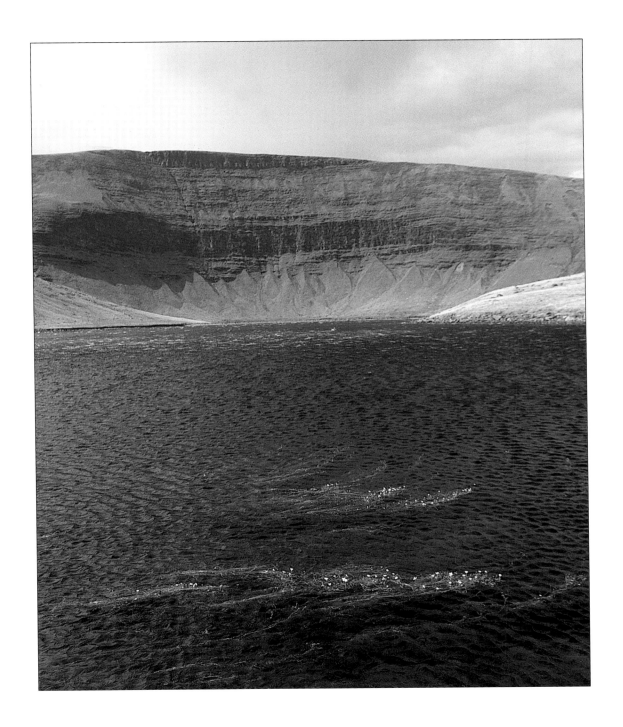

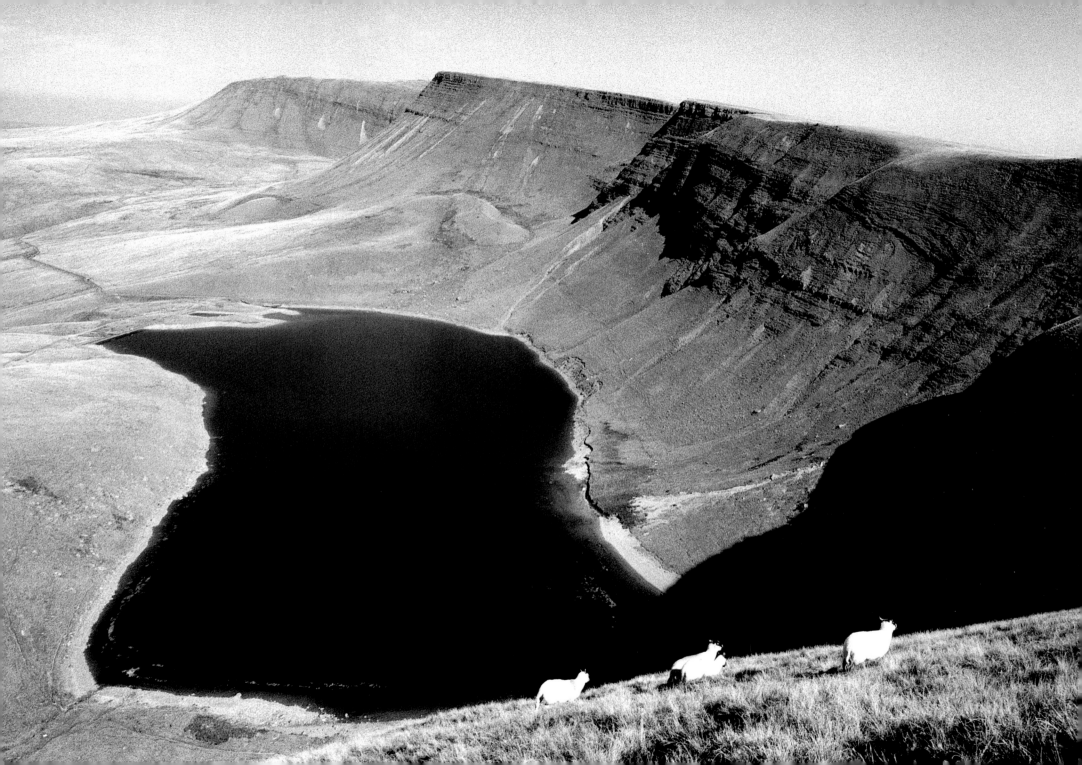

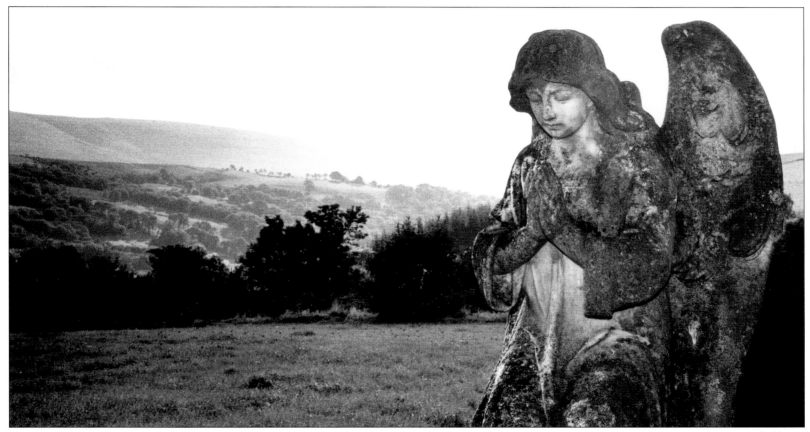

Llanddeusant

Mynydd Bach, Ceredigion

The economic condition of the rural community of Dyfed was desperate in the first half of the nineteenth century, especially after the Napoleonic wars. The population grew rapidly while the ordinary people fell deeper into merciless poverty. This crisis led to the Rebecca Riots where men rose up to destroy the Carmarthen poorhouse as well as the tollgates.

The poverty of the period also motivated Rhyfel y Sais Bach (the War of the Little Englishman) in Llyn Eiddwen and Mynydd Bach in rural Ceredigion. Augustus Brackenbury, the son of a wealthy family from Lincolnshire, bought nine hundred acres of common land and set about enclosing it. Although this was legal, it would have ruined the livelihood of scores of poor people that used the common land to graze their few sheep, cattle and geese. In the summer, when they grew hay on their three or four acres, they were totally dependent on this land.

Every time the men employed by Brackenbury erected barriers around the common they would be torn down at night and smashed. When he built a house for himself he was forced to hire soldiers to protect it. Shots were fired. Brackenbury was held and his house was set on fire. But the Englishman persevered. He built another house, easier to defend, calling it Castell Talwrn. A crowd of six hundred attacked the castellated house and set fire to that one too. Soldiers were sent to the region to arrest the leaders, but they all just happened to be away at the time!

Brackenbury was discouraged. He went back home to England, only to return within two years to build a house for the third time. But his stay was short-lived. He left Wales once again, and for good. The poverty of the ordinary people continued. Five thousand natives of Ceredigion had no choice but to emigrate to America in the middle of the century, and thousands more went to London and to the industrial valleys of Wales.

Castell Talwrn

two views of Mynydd Bach

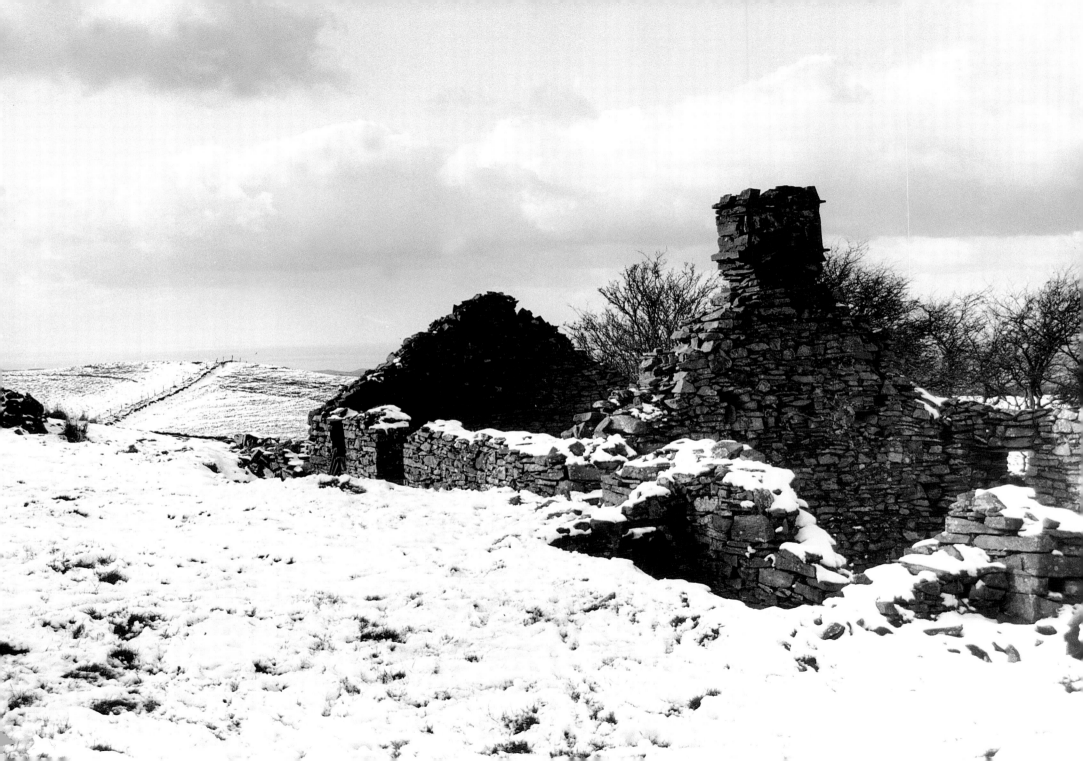

Epynt

Llandeilo'r-fân schoolhouse

In 1940 the most eastern Welsh community of south Wales was on the Epynt Mountain in Brecon. It was an ancient community where families had farmed the same land for centuries. The religious and cultural centre was Capel y Babell, on a hill above Cilieni River. Eighty children and four teachers attended the Sunday School. The annual Epynt eisteddfod and concerts were held there.

Vocal music was the main feature of Epynt's culture; their octets were renowned throughout a wide circle of eisteddfods. But the gaze of the War Office fell upon the enchanting beauty of Epynt and its valleys. It decided that this peaceful region would make an ideal site for practising their huge cannons. Of course, no one in Wales was consulted

rusty tractor, Llandeilo'r-fân

– an ancient Welsh community could not stand in the way of the War Office, any more than the cultured community of Cwm Tryweryn could stop the city of Liverpool from drowning that valley.

The mountain people demonstrated their united objection in meetings held from Pontsenni (Sennybridge) and Trecastell in the south to Tirabad and Llanwrtyd in the north. Oil lamps lit the meetings in the tiny schools of Llandeilo'r-fân and Merthyr Cynog, Cilieni and Llanfihangel Nant Brân. Welsh was the language of the meetings.

The opposition was in vain. By the end of April 1940, 65,000 acres had been possessed, more than two hundred people thrown out of their homes, and the old Welsh community was wrecked. Homes were turned into targets for weapons. Nothing remains of Capel y Babell but the foundations. Below on the banks of Cilieni are the practise fields of the SAS.

Gwybedog, Blaen Talar, Gilfach yr Haidd and Pant y Blodau are gone. In their place came Dixie's Corner and Piccadilly Circus, Canada Corner and Gallows Hill. At a cost of five million pounds a new uninhabited village was built, with a pub, a shop and a church, in order to play war games around houses with little weapons. A huge camp was planted, along with its English colony, near Pontsenni, and the village and its neighbourhood were almost totally Anglicised. Thus the government in London defended Wales.

two views of the Epynt

Rhydcymerau

yr Efail-fach

In his gem of a book, *Hen Wynebau (Old Faces)* D J Williams says that, 'Dafydd yr Efail-fach (of the Little-smithy) was the only out-of-the-ordinary man in the old area'. But it is unlikely that a more unusual man than D J himself had been brought up in the Cantref Mawr (Great Hundred) for centuries. One would have to go back to the time of Lord Rhys to find anything like the passion of his desire for national freedom. Although he was a pacifist all his life his spirit was with the patriots of the age of Gerallt Gymro (Giraldus Cambrensis).

The enormous range of his multitude of activities was heroic, though the nature of the heroism was somewhat different to burning the Bombing School. This great man of letters organised innumerable meetings and committees. He was diligent in raising funds, he sold pamphlets and wrote hundreds of letters to the local press.

When Plaid Cymru faced a financial crisis in 1964, D J transformed the situation, revitalising the spirit of the party, by selling Penrhiw, the old farmhouse, and giving every penny he received for it to Plaid Cymru.

Though the demands of this former collier were often heavy, his brilliant humour and his fine humanity made it difficult to refuse anything he asked. He treated everybody with a dignified humility. One day he arrived at the school where he taught in worn-out shoes. He had met a tramp on his way and had exchanged shoes with him.

the village's old pub

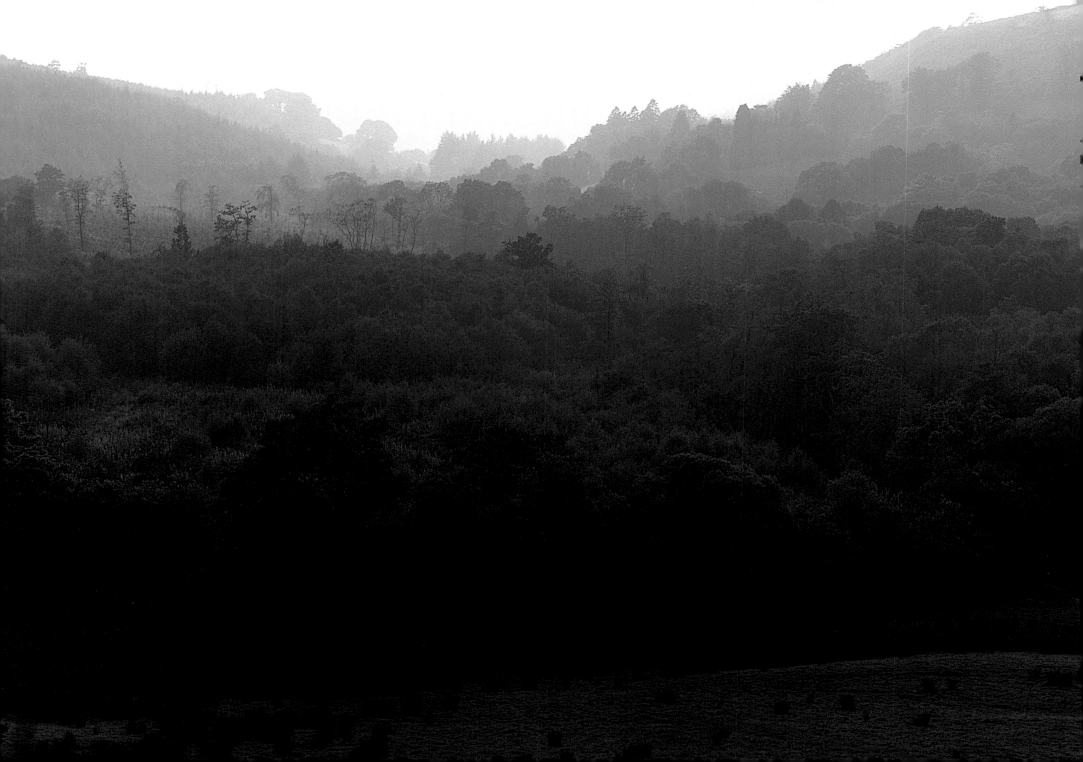

He was faithful all his life to his chapel and his minister, faithful to the Sunday school and the weekday meetings. But no one was less holier-than-thou. Even though he was a man of great depth, wherever D J was, there would also be laughter.

That is how it was on the last night of his life. He had gone to his old chapel in Rhydcymerau as chairman of a concert, organised to raise money for the Rhydaman National

Eisteddfod by D O Davies, a bosom friend who came from the same *milltir sgwâr* (square mile). The chapel was crowded. Half way

Rhydcymerau Chapel

through the concert the chairman was called forward, and the extremely funny first half of D J's address had the audience rolling with laughter. Then he became serious. We were taken back to the chapel as he remembered it in his childhood and his youth more than seventy years earlier, when there would be forty children reciting verses from the Bible. He named many individuals and families, noting the pews where they used to sit in that very chapel. He spoke with feeling of their values, and he made a fervent appeal to us in the audience to stick just as faithfully to those principles. 'They are around us tonight,' he said, 'a cloud of invisible witnesses.'

He walked back to his seat. He sat. A deathly shaking took hold of him. Within half a minute he had joined the cloud of witnesses, the circle of his life complete.

pathway, yr Efail-fach

Traeth Maelgwn

Early in the sixth century, according to legend, four Welsh kings met on a beach near Ynys Las opposite Aberdyfi, known ever since as Traeth Maelgwn (Maelgwn Beach). To decide which one of them should be chief, they agreed on a test. When the sea was at low tide the four sat on their thrones and faced the waves. The last to yield to the water would be accepted as king-superior. Maelgwn Gwynedd's three opponents were tossed into the sea while his own throne stayed on the surface of the waves. Five centuries later a similar story is told about Canute.

Maelgwn Gwynedd was probably the most powerful of the higher kings of Britain. A great-grandson of Cunedda, according to the lineage of Gwynedd, he was educated at Llanilltud Fawr at the other end of Wales, at the feet of Illtud himself. Gildas, who came from the Welsh kingdom of Ystrad Clud (Strathclyde) was a contemporary pupil of his, and also author of the Latin book, *The Fall of Britain*, where we learn most about Maelgwn. The book was written during the period

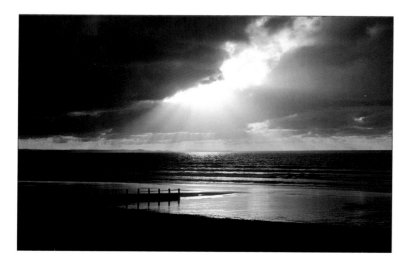

of peace that followed the triumph of Mynydd Baddon that is attributed to Arthur.

Gildas was a bitter prophet who wrote from the Romano-British Christian point of view. He poured scorn on five kings, but Maelgwn, whom he called the Dragon of the Island, received the most merciless attacks. He hated the 'knavish band' of poets that sang in Maelgwn's court in Degannwy, half a century before Taliesin and Aneirin.

Maelgwn was a firm ruler. He can be credited possibly for keeping the Germans immobile and quiet in England during his time. He was killed in 547 by the dreadful Yellow Plague that swept through Europe. It is said that the plague did not affect the German people as badly as it did the Britons, making a second wave of English invasion easier.

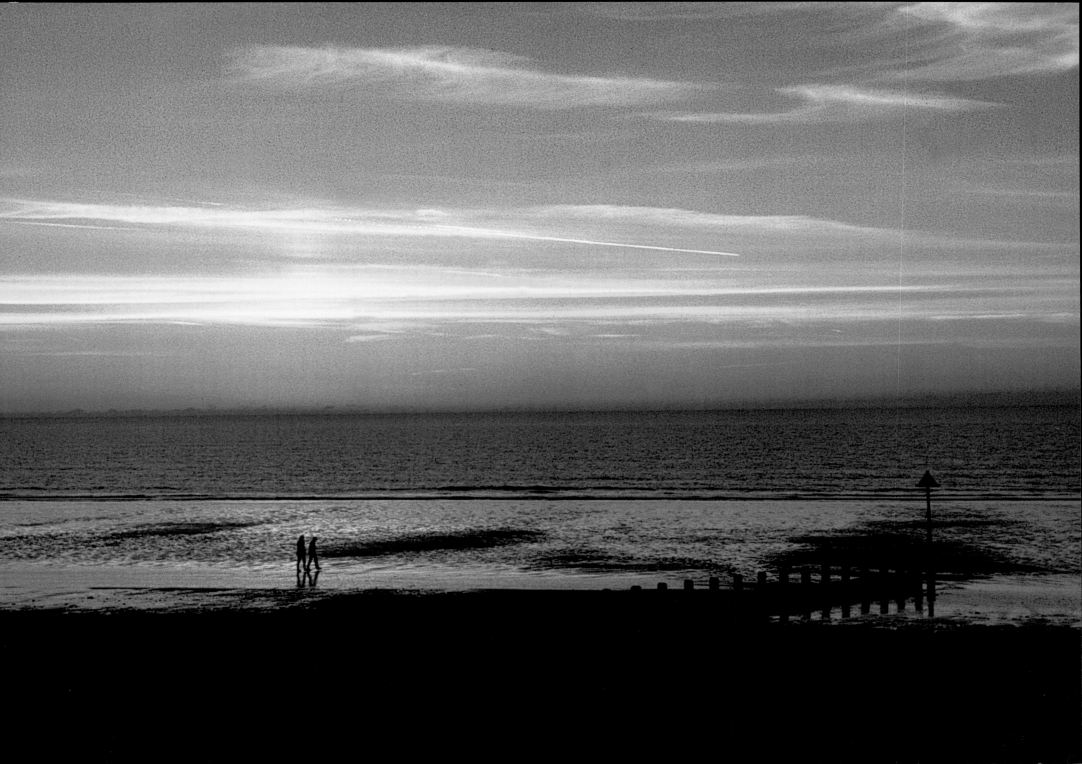

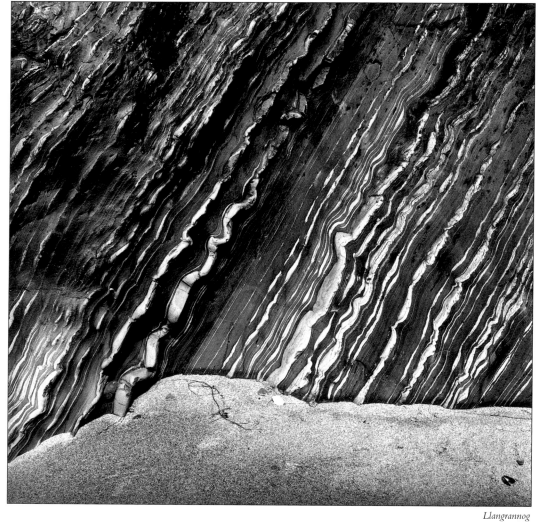

Llangrannog

116

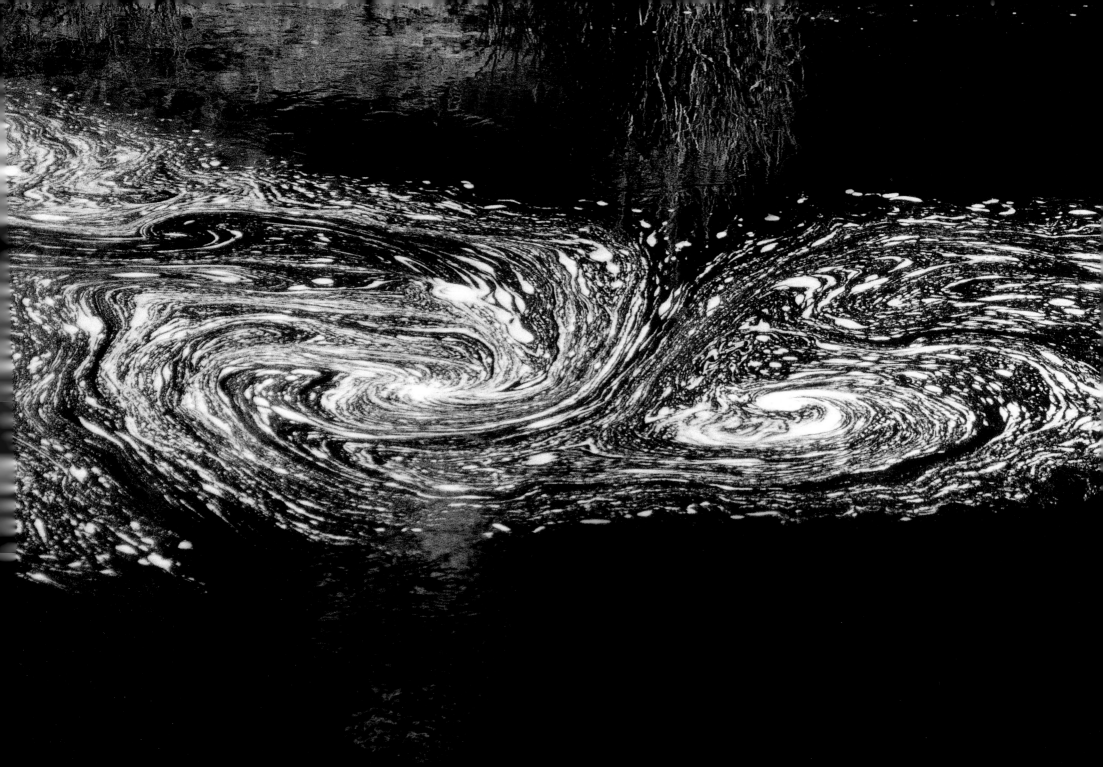

Cwm Cynllwyd

O M Edwards wrote once about a moonlit night over a century ago when he stood with Tom Ellis, who had been addressing a political meeting in Dinas Mawddwy, on Bwlch y Groes, where this picture was taken of Aran Benllyn. It was as light as day and there was a full moon, 'but we could hardly recognise anywhere,' said O M, 'everywhere was enchanted. The Aran, Craig yr Ogof, the Arennig and all those beyond were under a more gentle light than you could ever imagine. We felt that the mountains slept during the day, but now they had awoken, and had come to life. "You see, Owen," my companion said, "Wales has been transformed in front of our eyes. Will we live to see her really transformed?"'

Bwlch y Groes

O M Edwards was brought up in Cwm Cynllwyd at the foot of Aran Benllyn in a thatched cottage with an earth floor. Neither he nor his three brothers wore shoes from April to September. A mile from his home stands Llanuwchllyn where Michael D Jones was brought up, the nationalist that some regard as the greatest Welshman of the nineteenth century. O M fell deeply under his influence whilst at Bala. He said, after being in his company, 'When leaving Bodiwan we had decided we would do all we could for our country and her ordinary people.'

After he had been a fellow in history at Lincoln College, Oxford, for fifteen years, O M became Chief Inspector of Schools for the Board of Education in Wales for another fifteen. He died aged 62. His hard work made his contribution greater than any previous effort to strengthen the state of the Welsh language. He wrote interesting and influential books; he published magazines such as *Cymru* and *Cymru'r Plant* and scores of volumes like *Cyfres y Fil*. On top of all this he gave himself unsparingly to the task of making a totally English education system more sympathetic and relevant to the Welsh people.

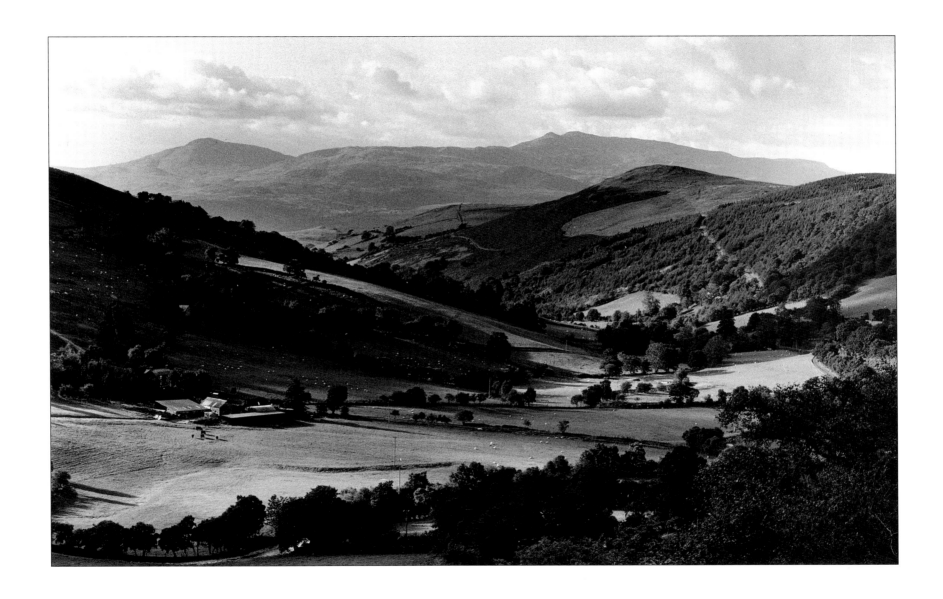

Cader Idris

Cwm Prysor

Dim ond lleuad borffor	(Just a purple moon
Ar fin y mynydd llwm	On the edge of the bare mountain
A sŵn hen afon Prysor	And the sound of the old river Prysor
Yn canu yn y cwm.	Singing in the valley.)

Hedd Wyn was the product of the intellectual culture of the common folk of Wales. His only formal education was at the village school in Trawsfynydd. He was formed by the informal education of his region. In his home and his neighbourhood he mingled with ordinary people who had a lively interest in matters of the mind and spirit, especially poetry.

The chapel was the cultural centre of Trawsfynydd; the poet and minister were the leaders of the community. Hedd Wyn featured prominently in both the religious and cultural life; he was a Sunday School teacher, a conductor of choirs, a compere of concerts and eisteddfods and he contributed to the thought-provoking society of the chapel as well as to the ongoing debates in the village.

As a young man he spent much of his time in the company of poets and writers and at the eisteddfods in Meirionnydd. He liked the company of the lads in pubs and he had quite a number of girlfriends. To his region he was an essential figure, a *bardd gwlad* (country poet, offering a kind of bardic service) celebrating marriages and births in poems, and expressing in elegies the feeling of the neighbourhood at the loss of one of its inhabitants. He developed into a skilful poet of some significance.

But his greatest work was 'The Hero' which won the chair of the National Eisteddfod at Birkenhead. A month before the day of the chairing ceremony Hedd Wyn was killed in the battle of Pilken Ridge, at Passchendaele, where, as he himself wrote,

a gwaedd y bechgyn llond y gwynt	(the cries of the boys filled the wind
A'u gwaed yn gymysg efo'r glaw.	And their blood was mixed in with the rain.)

In the madness of the Passchendaele battles Britain and Germany lost between them over half a million young men.

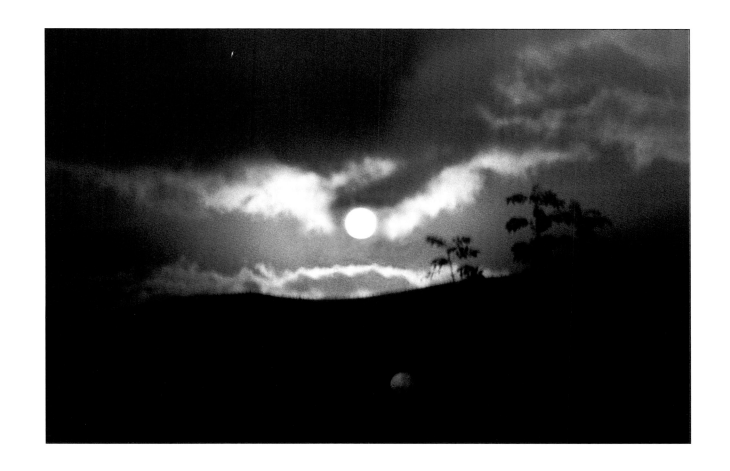

Abergeirw

I became familiar with Abergeirw, a hilly region a few miles north-east of Dolgellau, during general elections. It was one of the places we would go to last of all to hold public meetings, in the four elections I fought between 1945 and 1959. Although it would be after eleven at night when I arrived in this welcoming and cultured area, almost everyone in the audience would stay for supper after the meeting. I was staying in Y Ganllwyd at the time of this story which I am going to relate.

I heard that seven or eight miles could be taken off the usual journey through Dolgellau by crossing the bridge over the River Mawddach. I set off in the direction of the bridge. After a few miles the road deteriorated. As there was nowhere to turn the car, I had to carry on. The road deteriorated further and the left wheels fell into a ditch. I couldn't move the car. I walked back to look for shelter, and to my surprise I noticed a light in a cottage on the other side of the little valley. I went there in the hope of being offered a chair to sit in for the night. I knocked on the door for some time but to no avail. This didn't surprise me; it was the early hours of the morning. I continued to say who I was and, after a while, I heard a woman's voice. When she came to the door she was dressed from head to foot in sacks that rose to a point on her head. I was taken to the kitchen where her sister, dressed exactly the same, was sitting in front of an open fire. I had a chat with the two, who were extremely gracious with their welcome. They refused to listen to my request for a chair to sit in until morning – I had to have a bed. One went upstairs to prepare it, then I was taken by candle-light to the bedroom. This was a cupboard bed. I had only once before in my life ever seen a cupboard bed, let alone sleep in one, and that was in the National Museum. But I sank delightfully into the luxurious depth of the feathers, full of gratitude, and slept soundly for seven or eight hours.

In the morning a wonderful aroma of breakfast wafted from the little kitchen. I will never forget the welcome of those sackcloth sisters in an isolated cottage in Abergeirw. After leaving them, I then came across a company of foresters. One of them brought a tractor to pull the car to the road and found a place to turn it. It must have been the kind foresters who spread the story through Meirion before the end of the day that I had spent the night in Abergeirw with two old spinsters!

Tryweryn

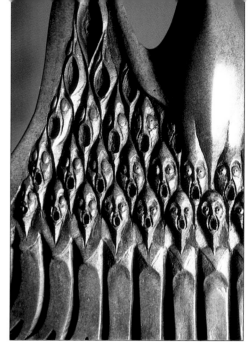

The nature of the relationship between the London government and Wales was never revealed more harshly than when the fine community of Cwm Tryweryn was broken up in the 1960s and the homes drowned. The plans of Liverpool City were opposed by a strength and unity the like of which had never been seen in Wales. Only one Welsh MP backed the Liverpool measure in the Westminster parliament; his name happened to be David Llewellyn. But the Welsh Members of Parliament only constitute an eighteenth part of the House of Commons. The bill passed smoothly through Parliament. Cwm Tryweryn was drowned – the homes, the chapel, the village. One of Wales' most cultured communities was destroyed. For what purpose? To supply the industries of Liverpool and the suburbs of Merseyside with cheap water.

detail from the Tryweryn Memorial
by John Meirion Morris

The first the people of the valley heard of the Liverpool city plan was in a report in the *Liverpool Daily Post*. There had been no consultation with anyone in the neighbourhood, nor in the county, nor in Wales before the arrogant announcement was made. A Defence Committee was immediately set up with Elisabeth Watcyn Jones as the extremely efficient secretary. She had been born in Capel Celyn, the village in the valley, daughter of Watcyn of Meirion, the posmaster, a male voice choir conductor and an authority on *cerdd dant*.

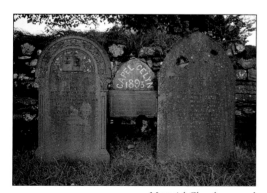

Memorial Chapel graveyard

A wave of objection swept throughout Wales. Liverpool Council was asked to receive a national deputation. It refused. A huge demonstration was held in Liverpool and in many places in Wales, including a rally attended by two thousand people on the banks of Tryweryn. The entire population of the valley bravely walked through the city of Liverpool, and they all went to Manchester to make a television programme for Granada. When three of us tried to address Liverpool City Council we were thrown out by the police in the middle of a deafening tumult. One hundred and ten councils and public bodies, including trade unions, supported the opposition to the plan. Nevertheless, despite the protests of an entire nation, the valley was drowned. This wicked action resounds to this day as an example of how little control the Welsh people really have over their own lives.

Llanrhaeadr-ym-Mochnant

To thousands of visitors the only attraction to Llanrhaedr-ym-Mochnant is Pistyll Rhaeadr, one of the seven wonders of Wales. But well-read Welsh people associate the area with the name William Morgan. When he was vicar of Llanrhaedr-ym-Mochnant he achieved, in 1588, the amazing feat of translating the scriptures from Hebrew and Greek into the classical Welsh of the poets. Wales was the only stateless country with a Bible in its own language. William Morgan's version was founded upon William Salesbury's unacceptable translations of the Epistles and the Gospels of the *Book of Common Prayer*.

It is not an exaggeration to say that the translating of the Bible changed the history of the nation, in religion, in culture and in language. It made an immeasurable contribution towards saving the language that was badly threatened by Wales' geographical location and by cultural, economical and political pressures from the nation that had annexed the country.

Christianity had been a source of unity and strength to Wales and her language since the Age of the Saints. The Church and its monasteries had been the main medium for her higher culture throughout the Middle Ages. The country was transformed by the huge spiritual awakening in the eighteenth century. From Sunday to Sunday a refined Welsh could be heard. People were impelled by the revival in their scores of thousands to read the Bible. A large proportion of the Welsh learnt to read in the schools of Griffith Jones and later in the Sunday schools. In the nineteenth century and the beginning of the twentieth great crowds of workers and their families worshipped in the chapels. All this kept the Welsh language alive despite the overwhelming pressure of the English language – the most powerful language in the world – and the oppressive immigration, and at a time when Wales as a country had no national, political, legal or educational institutions. If the Welsh language had disappeared as did the language in the Welsh kingdoms in the Old North, the Welsh nation would have vanished as completely as did the Welsh communities of Elfed, Gododdin, Rheged and thereafter Ystrad Clud (Strathclyde).

above the waterfall

Llanrhaeadr

Dyffryn Ogwen

An obvious and attractive characteristic of the communities around the slate quarries of Gwynedd is the liveliness of their culture. The unhealthy and dangerous work undertaken by the labourers did not stop them from enjoying matters of the mind and spirit. Having toiled on their smallholdings the quarrymen attended a variety of cultural societies in their spare time, many of them connected to the chapel.

Welsh was their first and often their only language. In 1890 the census showed that Welsh was the only language of 69 percent of the people of Gwynedd, and in the quarries region the proportion was substantially higher.

The most fascinating part of quarry life was the cabin. The quarrymen took their midday meal there, but the cabin was much more than a canteen. It was a business centre and more especially a cultural centre with officers to maintain order. There the quarry workers sharpened their minds in debates, political and religious discussions, literary and intellectual competitions, and took part in eisteddfodic recitation and singing competitions, sometimes held monthly. This vibrant cabin life proved that the folk culture of Wales was not an empty myth.

crawiau, slate slab fence

Dinorwig Quarry

slate wall, Aberllefenni

Garn Goch

A century and a half after the departure of the Romans from Britain only a small part of the island was in the possession of the English, a somewhat different position from the speedy successes of their fellow savages on the continent. However, in the second half of the sixth century, a terrible disaster struck the Britons. The Yellow Bubonic Plague killed some sixty

the Memorial Stone

percent of them in the south-east – from Cornwall, past the upper Thames, as far as the regions of Coventry, Nottingham and Sheffield. The plague had come to Britain through the harbours in the south-east that traded with the Mediterranean countries. Because the English did not trade with those countries the plague did not affect them. This enabled them to press on through opposition which was feeble or non-existent. In some parts of the country they walked into emptiness.

Apart from Strathclyde, where Welsh survived for another two or three centuries, the only Welsh-speaking Britons in the eighth century were the Cornish and the Welsh. The Welsh had developed into a nation during this Age of the Saints, with territory, language, religion, history, law and traditions to differentiate them from the pagans to the east.

The Welsh have always been a small nation with their backs against the wall. This was never more obvious than during the two centuries of war against the Normans, the most skilful soldiers of the age. The Welsh fought by guerrilla warfare usually, though there were several big battles. A fateful battle was fought in the south on a moor between Llwchwr and Swansea. Under Hywel ap Maredudd the men of Brecon attacked the strong Normans and English of the Gower on New Year's Day 1136, beating them soundly. A stone denotes where the battle took place.

Caernarfon

It is appropriate that it was at Caernarfon that the architect Dewi-Prys Thomas's main achievment, the Headquarters of Gwynedd Council, was built. One of Wales's most famous buildings, Edward I's Castle, also stands in Caernarfon, close to Gwynedd's Headquarters. The two buildings represent very different aspects of Welsh history, but at the same time Dewi-Prys's building had to suit the atmosphere, 'and sing a duet with the Castle'.

Eryr Eryri, Gwynedd Council's Headquarters

Dewi-Prys Thomas's Welsh identity was central to his work; the history and culture of Wales influenced him, and he believed that the country's landscape and form were reflected in its buildings. He once said, "... as you travel through Wales, you see, time after time, the way the buildings themselves, Man's creation, reflect the magic of God's work." His Welshness radiates through the extremely interesting Headquarters of Gwynedd Council in symbolic designs, such as the large square that is a memorial to Llywelyn ap Gruffudd. Lord Snowdon interfered to prevent the prominence that Dewi's plan gave to the Tower of Gwynedd's Strength, but the building is an expression of Wales's independence, contrasting with its stone neighbour, the castle.

Caernarfon

drawing by Dewi-Prys

Professor Dewi-Prys Thomas was the Head of the Welsh School of Architecture for twenty-one years. His main contribution was the way he inspired hundreds of his students. He ensured that at least half of the students were Welsh, and this at a time when thousands of English students flowed into the colleges of the University of Wales. None of his students could ever forget the way he would show a piece of poetry in Welsh in *cynghanedd* (strict metre poetry) on the screen, connecting the consonants and the rhymes with a network of circles and lines to make a pattern very similar to Celtic knotwork. He used to say, "... the Celt is different – complexity enchants us... the abstruse line... the circles, like tapestry."

Bryn-celli-ddu

Carnhuanawc believed, in the first half of the nineteenth century, that ordinary folk of no other country treasured its national culture and literature as the Welsh did. Men of learning responded to this hunger for knowledge – they too had risen from among the ordinary people. An example of these autodidacts is Gweirydd ap Rhys, Robert John Pryse, the most significant writer from Ynys Môn in the Great Century.

Gweirydd was born in a barn in Carreg-lefn, and was brought up at Llanrhuddlad. His mother died when he was four years old. At the age of eight he went to work as a farmhand. His father died when he was eleven and he was apprenticed by the parish to a weaver. The only formal education he ever received was two days at school. Nevertheless, through enormous endeavour, his literary output was astonishing. The most famous of his books is *Hanes y Brythoniaid a'r Cymry (The History of the Britons and the Welsh)*. It encompasses the history of the Welsh and their ancestors from the time of the wonderful cromlechs that are found from Pentre Ifan in Preselau to Bryn-celli-ddu on Ynys Môn. Sir J E Lloyd claimed that he was brought up on these books.

Barclodiad y Gawres

His *History of Welsh Literature 1300 to 1650* and his *History of Welsh Literature 1651 to 1850* are highly praised. It was Gweirydd ap Rhys who mostly edited all four volumes of *Enwogion y Ffydd (Famous People of the Faith)* and an edition of the *Myvyrian Archaiology*. He published the works of Iolo Goch, the *Life and Times of Bishop Morgan* and an *Orthography of the Welsh Language* jointly with Thomas Stephens, the scholar-chemist from Merthyr Tydfil.

He published a Welsh grammar and four dictionaries. When Thomas Gee published *Y Gwyddoniadur (The Encyclopaedia)* in ten volumes of nine hundred pages each, at a cost of £20,000 – the greatest Welsh literary undertaking ever – Gweirydd ap Rhys went to Denbigh to assist him, contributing five hundred articles. Demand was such that a second edition was published. On top of all this, Gweirydd founded the first musical societies of Môn. As Sir Thomas Parry said, 'Gweirydd ap Rhys should be regarded as one of the nation's foremost heroes.'

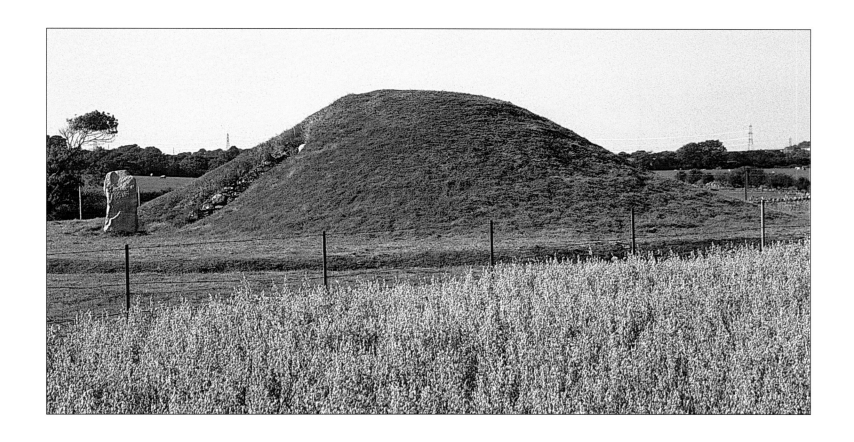

Penyberth

The Conference for International Disarmament in 1931 foresaw the terrible destruction that bombing from the air could cause among civilians in a future war. Therefore an international agreement was sought in order to prevent it. The only Great Power that objected was Great Britain, and although only Iraq, Persia (Iran) and Siam (Thailand) supported it, the British opposition was enough to defeat the pact. Ten years later, possibly as many as 150,000 men, women and children were killed in Dresden by such bombing.

the memorial to the three at Penyberth

In order to train men in this devilish craft the government announced its intention to set up a bombing school in Llŷn, in an historical region where the culture of Wales was richest and Welsh idiom purest. An historical house, where pilgrims stopped to rest on their way to Enlli, was destroyed. It was intended to establish two similar schools in England, one at Chesil Beach in the south and the other in Northumberland in the north.

These two bombing schools were successfully opposed, the one because there were breeding swans nearby, and the other because Holy Island, which is of historical importance to England, was not far away. The Government refused to receive a national deputation from Wales, and *The Times* refused to publish a letter signed by a large number of the foremost Welsh people. The national opposition, which was supported by 1,500 public organisations, was totally ignored.

Having exhausted all forms of legal protest, and taking care that no one would be personally harmed, wood and sheds at Penyberth were set alight by three great Welshmen, namely Saunders Lewis, D J Williams and Lewis Valentine, who then immediately gave themselves up to the police. The jury in Caernarfon Court failed to find them guilty. The case was transferred to the Old Bailey in London where a jury of Englishmen could be depended upon. The three were imprisoned in Wormwood Scrubs for the most self-sacrificing act since the days of Owain Glyndŵr.

Ynys Enlli

In the Middle Ages Ynys Enlli (Bardsey) in the north corresponded to St David's in the south as a shrine for pilgrims. It was thought of as an holy island, the island of saints. According to tradition, twenty thousand saints were buried there.

Mae yno ugain mil o saint
Ym mraint y môr a'i genlli
Ac nid oes dim a gyffry hedd
Y bedd yn Ynys Enlli.

(There lie twenty thousand saints
In the honour of the sea and its torrent
And nothing will disturb the peace of
The grave on Ynys Enlli.)

In the sixth century a monastery was founded there which continued until 1537. Almost six centuries after it was founded the monks accepted the rule of the Austinian Canonists, or the Black Brothers – like the Cistercians, they promoted Welsh culture, copying manuscripts and supporting poets. Among those who sang the praises of Enlli priory was Lewis Glyn Cothi from Dyfed. A population of about fifty stayed until 1926, when the majority moved to the mainland, including their 'king', Love Pritchard, who was elected by the islanders to settle disagreements.

Even in our materialistic age, the Isle of Enlli remains a permanent symbol of Welsh spirituality, just as Penyberth symbolizes the readiness of the Welsh to challenge injustice, and to survive as a nation. In spite of all the changes that have taken place in our country since the age of the hill forts, Wales survives.

The nation which we know as Wales has existed for one thousand and six hundred years. It was in the year 383 that Macsen Wledig (Magnus Maximus) gave some leading families the responsibility for their own defence, thus creating the core of a future nation. In 1983 I asked Dafydd Iwan to celebrate this event in song, and this he did in his famously defiant *'Yma o Hyd'* ('Still Here').

The same spirit of confidence is expressed in the well-known words of Waldo Williams, the poet of the Preselau. In a tumultuous new century that is likely to see the end of the world's biggest empire, his prophetic words remain as relevant as ever,

Daw dydd y bydd mawr y rhai bychain
Daw dydd ni bydd mwy y rhai mawr

(And the little will one day be great,
And the mighty will no longer be.)

ACKNOWLEDGEMENTS

I would like to thank the following:

The National Museum of Wales for permission to photograph at the
museum in Caerleon.
Llantwit Major Church for permission to photograph.
Medi James for capturing me unawares on camera (page 7)
My neighbour, Elisabeth Jones, for feeding my chickens during my long
absences.
Y Lolfa for their care in producing this book, with particular thanks to
Ceri for his diligent work in scanning the images, and to Mared for her
patience.
To the Welsh Books Council for their financial assistance.
Lastly, a very warm thanks to Gwynfor and Rhiannon for welcoming me
to their home at Talar Wen and for their genial company.